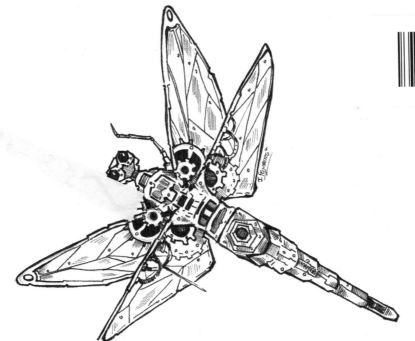

How to Draw & Paint
Fantastical Clockwork

*Written and Illustrated
by Jessica Cathryn Feinberg*

With special thanks to:

All fans, friends, and Kickstarter backers
whose support made this book possible.

My editor - Victoria Morris
My proofreader - Janet

Contents

Author's Note

I first started drawing clockwork creatures in 2001. Over the last 14 years the interest in clockwork and steampunk has grown by leaps and bounds.

In 2012 I started using Kickstarter to fund my projects. My very first project was *The Clockwork Menagerie*. This was a small book intended to be both a decorative art piece and instructional guide on drawing clockwork creatures.

I was happy with the basic information offered by *The Clockwork Menagerie*, but I knew I eventually wanted to do a more in depth clockwork book covering drawing and painting. Now, three years later, I'm thrilled to present another successfully funded Kickstarter project: *Drawing & Painting Fantastical Clockwork*.

This book includes basic clockwork drawing techniques with lots of examples! Plus there's also information on design, generating ideas, shading and a number of different coloring techniques.

I hope this book sparks your imagination and helps you create your own unique drawings. Stay positive, have fun and go make art!

Thank you!

Jessica Cathryn Feinberg

How to Use this Book

The creatures in this book are drawn using this basic process:

1. Basic Shapes
A few basic shapes are sketched as a blueprint.

2. Detailed Sketch
The blueprint is used to create a detailed sketch.

3. Finished Drawing
More details and shading are added using pencil or pen followed by (optional) color.

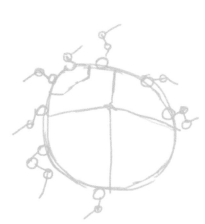
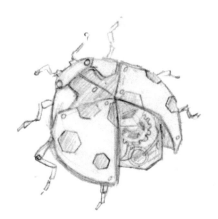
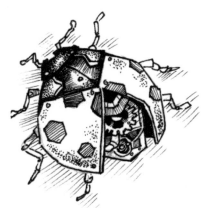

This book is split into three main "sections" for ease of use:

The Basics
Basic information about reference, layering shapes, designing creatures, and the materials used in this book (pencils, paper, pen, watercolor etc).

Creatures & Techniques
A series of step by step demonstrations on drawing specific creatures as well as example of how to work in pencil, pen, liquid ink, colored pencil, watercolor, and digital color.

The Parts
The last section shows ideas for drawing different types of parts individually (gears, clocks, wings etc). These can be incorporated into any drawing as well as helping you design your own, new, parts.

The Basics

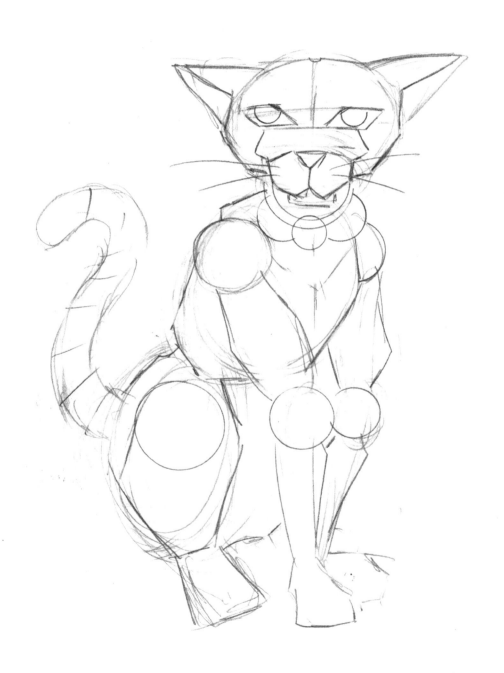

Reference & Inspiration

Reference pictures are very important when you are drawing animals. This includes fantasy creatures and clockwork versions of animals.

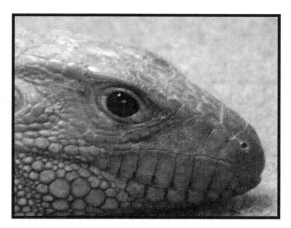

The best reference pictures are photos you take yourself! This is because seeing an animal in person gives you a better impression of its behavior and personality. Plus it allows you to take multiple photos so you have more angles and poses to look at when you are drawing.

You can also use wildlife field guides and the internet to find reference pictures, but it is important to be aware that most photos are copyrighted. You do not want to copy them exactly in your drawings, but it's usually okay to get ideas from multiple photos sources.

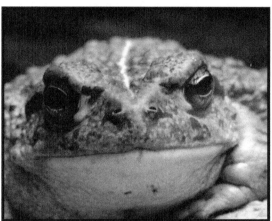

Take a sketchbook everywhere. That way you can get your ideas on paper right away. You never know what may inspire you!

If you need some inspiration for a unique design try looking at something you wouldn't normally connect with your project. For example you might look at animal skulls, rocket ships, cacti, or random objects around your house.

If you get really stuck on a project don't beat yourself up! Take a break and take a walk or listen to music. These can relax your mind and help with the creative process. You might also try sketching or doodling something different for 15 minutes and then go back to your project.

Materials

Here's a look at the materials I used for the artwork shown in this book. You should explore other materials as well and pick the ones that work best for you.

PAPER

For pencil and pen drawings I use standard white cardstock (any brand). You can also get colored cardstock if you want to draw on something other than white paper. For painting I use Canson XL Watercolor paper. It is durable, affordable, fairly easy to work with, and handles pencil, ink and watercolor well.

PENCILS

I use a mechanical pencil or a decent quality drawing pencil with HB lead. Make sure whatever pencil you choose is something you can draw lightly with and erase without damaging the paper.

ERASERS

I recommend an artist's "kneaded" eraser and also an extendable eraser stick. There are a number of brands of both of these available at most art stores.

PENS

The pen drawings in this book were done using Medium and Fine Sharpie Pens. They are waterproof, very durable, affordable, and easy to find.

LAYOUT TOOLS

While not required, tools like rulers and architects templates can be handy.

You can also trace around household items such as jar lids and coins to get circles and other shapes.

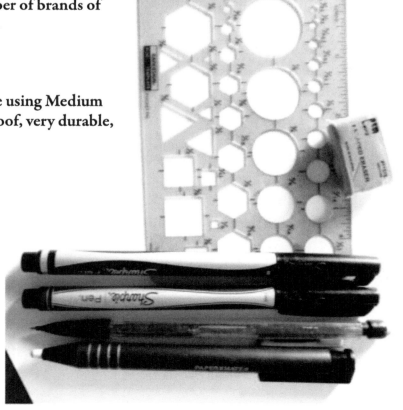

LIQUID INKS

I use white ink for adding highlights to my drawings and paintings. It can also be handy for fixing mistakes. I use brown and black ink when inking with a brush. The brand I recommend is FW Acrylic Artists Ink (it comes in many colors and isn't too expensive).

COLORED PENCILS

There are many brands of colored pencils available. I suggest going to an art store that allows you to test them to see what you like best. The colored pencils used for the examples in this book are Prismacolors. A good pencil sharper and a brush for dusting off your drawing are also handy.

WATERCOLOR PAINTS

Watercolors can be purchased in tubes or pans. I prefer using tubes and filling my own palette. If you plan to travel with your paints you should invest in a palette with a lid. You can mix most colors with these three: Lemon Yellow, Ultramarine Blue, and Permanent Rose.

You may find it handy to have a set with a variety of colors. I recommend a set of Sakura Koi watercolors as they are fairly affordable and have great colors.

BRUSHES

I use Princeton watercolor brushes. These are affordable and come in many shapes and sizes. I suggest a larger "dagger" or "round" brush (4 or 5 in size) and some smaller "round" or "liner" brushes for details (size 0 or smaller). The sizes you will need depend on the size you plan on painting. Experiment with sizes and shapes to see which brushes you like best.

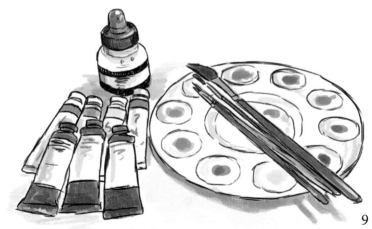

DIGITAL TOOLS

I use a scanner, Wacom drawing tablet (a drawing tablet is a must for digital drawing and painting) and Photoshop. The digital techniques in this book can be used with most painting software.

Building with Shapes

Drawing clockwork creatures starts with simple,
larger shapes like the ones used for these owls:

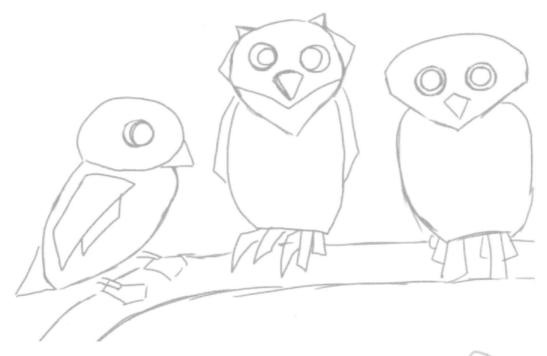

Even very complicated drawings start with
basic shapes like these.

To figure out the basic shapes for a creature
just picture drawing an outline around each
part of the animal – the head, the eye, the
nose, the ears, the paws, the feet and so
forth.

Always pay attention to parts of the animal
that are "iconic". For example we know the
shapes at the right are a rabbit because of
the ears, head shape, and tail.

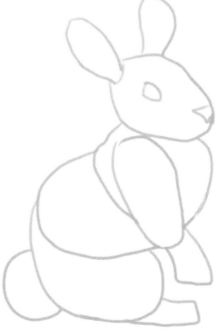

The basic shapes help you plan where the creature will be on the paper. That way you can pose and position it before putting a lot of time into the details. They also act as a blueprint for building the details on.

Once you have your basic shapes in place you can decide where to put smaller shapes to create parts like gears, bolts, pipes, vents and so forth. The last section of this book is filled with ideas for drawing these kinds of parts.

If you aren't sure where to add parts try looking for places where your creature needs to bend or move such as the shoulder, elbow, knee etc.

You will probably want to break up the larger shapes into sections (assuming the creature was built from a number of parts).

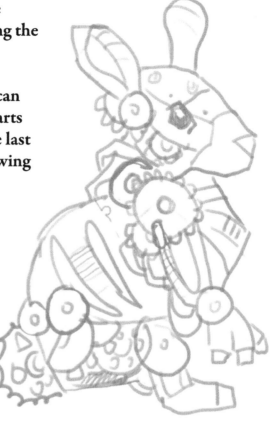

The owl shown here uses some simple straight lines to break up the head shape and add dimension and depth.

Reference pictures can help you figure out where to create these shapes - look for angles in the face, muzzle, beak and so forth.

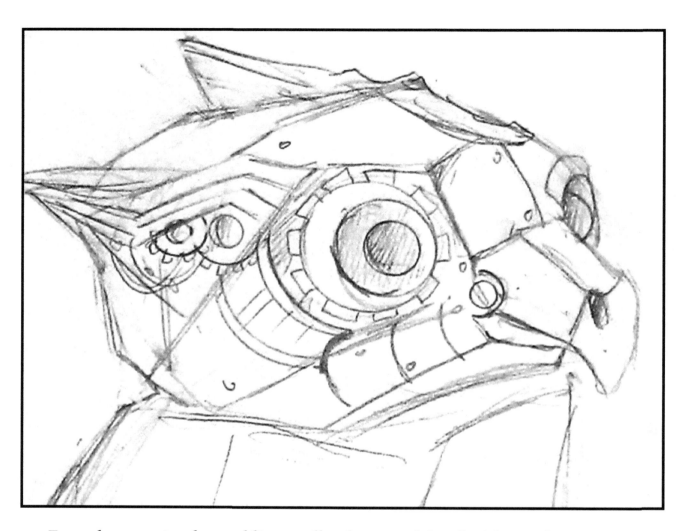

From there you just keep adding smaller shapes and details. This is where designing your creature really starts to get fun! Remember parts should overlap so layer your shapes on top of each other in some areas.

You can also experiment with mixing straight lines and curves in your drawings. Breaking up the straight lines in an area (like near the owl's beak to add a screw) makes the drawing a lot more interesting.

Take care when adding details. If you detail the entire drawing everywhere it may get confusing. Use more detail around areas like the eyes to create focal points.

Next you can add ink or color or simply use more pencil to create a finished drawing.

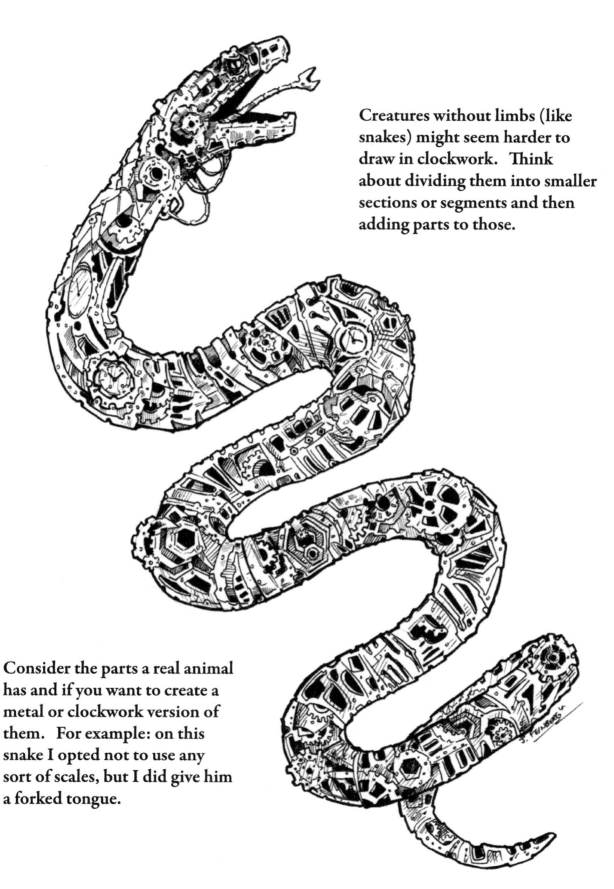

Creatures without limbs (like snakes) might seem harder to draw in clockwork. Think about dividing them into smaller sections or segments and then adding parts to those.

Consider the parts a real animal has and if you want to create a metal or clockwork version of them. For example: on this snake I opted not to use any sort of scales, but I did give him a forked tongue.

13

Creating Depth

There are a number of techniques you can use to create a sense of depth in your drawings:

Overlap
Place some elements of your drawing in front of others. Arms, legs, and wings may overlap parts of the body, or each other. Gears may overlap each other and other elements as well.

Shading
Use shading to make some areas darker while leaving others lighter. For example: the belly of a creature is usually darker than the top (unless its lying on its back!).

3D Edges
Simply add an extra line to ONE edge of a shape to create more depth. For example the "Clockroach" shown below has edges added to his legs that create more dimension.

Cut-Aways
Consider having areas of your creature open to reveal the inner clockwork. This is easy to do by showing parts of gears peeking out.

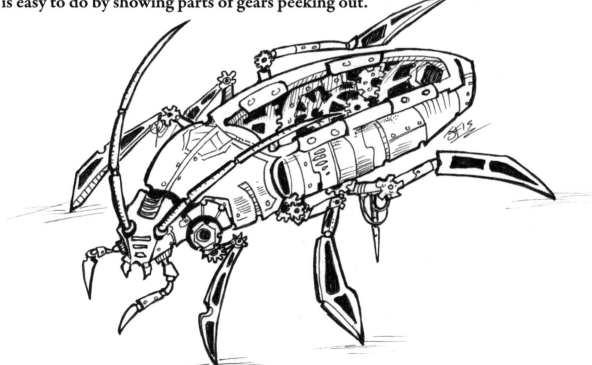

Here are some of those depth techniques at work!

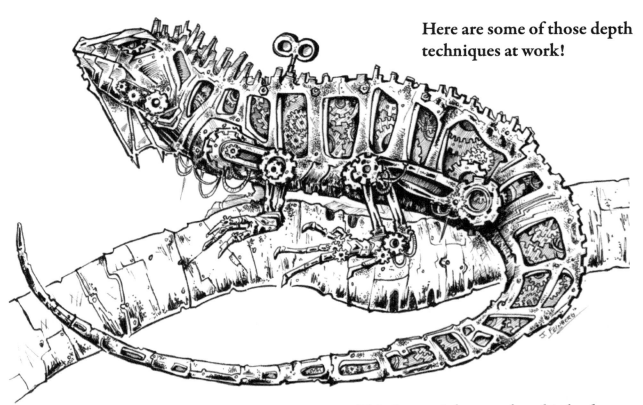

This Iguana's leg overlaps his body. There is darker shading behind it as well as under his belly.

The cut-away shapes with the white edge and darker shading inside, plus the gears peeking out, all add to the feeling of depth - it seems like we're looking inside the creature.

Also notice that his feet on the far side are drawn with light outlines and shading. They are farther away from us so making them lighter and less detailed creates depth.

Design Considerations

When designing creatures here are some other things to think about:

Functionality

Does your creature have specific tasks it performs? For example if you were creating a clockwork cat to catch mice then part of the design might be a cage or mousetrap. Does it need to swim? Climb? Breathe fire? Cut things? Talk? What your creatures does should dictate a lot of its design.

Power Sources

How is your creature powered? Steam? Magic? Electricity? Consider what sort of power makes your creature function and if this would visibly show in your drawing. For example a wind up creature might have a key or crank. A steam creature may have vents. If your creature charges via being plugged in, where is the plug? These considerations can make more interesting, believable designs.

What size is it?

If your clockwork creation is a recognizable animal like the bunny shown at the right, take a moment to consider its size. Is it the same size as a real bunny? Or is it tiny, only visible with a magnifying glass? Or perhaps huge enough to smash tall buildings? If your creature is a specific size you will want to consider how you can communicate that.

You may want to add another object, animal, or even tiny stick figure people to create scale. Or simply write the creature's name and size below it on the paper.

Mood

The unicorn below clearly isn't very happy! To create an angry mood I used very straight lines and a triangle for the eye. This makes the unicorn look a bit mad to start with. Add the motion lines, position of the hoof and the "steam" shooting out of the nose and we have an angry unicorn. Here are some tips for creating moods in your drawings:

• Softer, rounder lines are more friendly looking while sharper, harder lines are more scary or angry looking.

• The shape of the eye sets the expression and impacts the mood a lot. Big, wide open eyes are friendly while narrow, slanted eyes are more angry.

• The mouth is also VERY expressive. Try different shapes and angles to change the mood.

• Pose and body language can also communicate a mood. Study the body language of different animals to see how they express themselves.

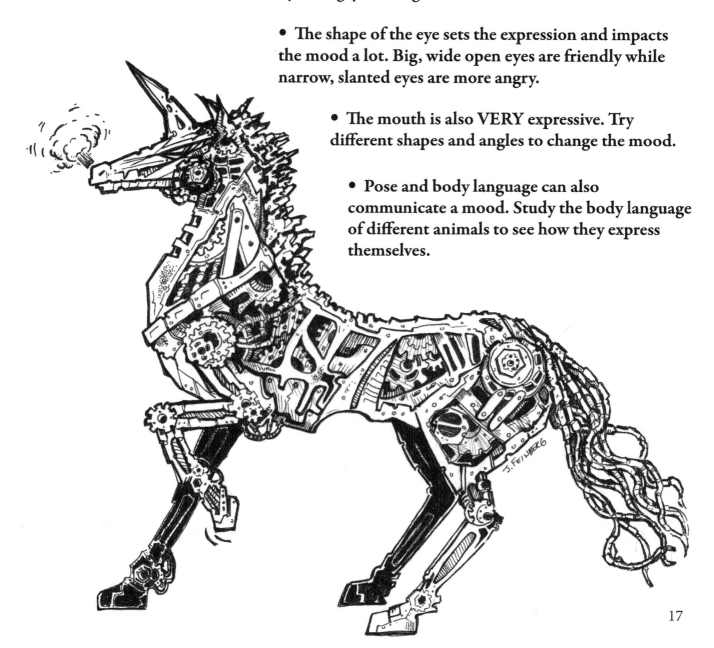

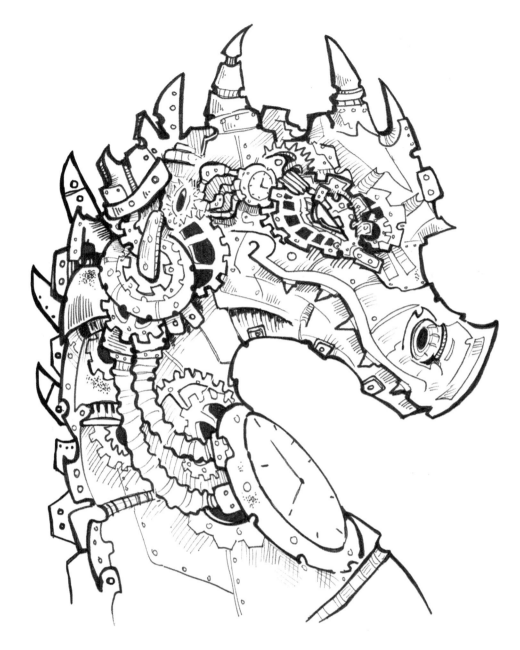

Creatures &
Techniques

Bee
Drawing with Pencil and Pen

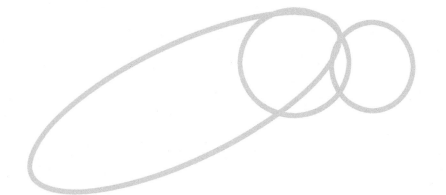

Insects are fairly easy to draw in clockwork so we'll start with a clockwork bee.

The basic body for the bee is an oval at a slight angle and two circles.

Next we can place the eyes with more ovals and add in wings and antennae:

You can start to tell what this creature is with just a few shapes! Once you have used some of the examples in this book you will find it easier to figure out basic shapes for new animals yourself.

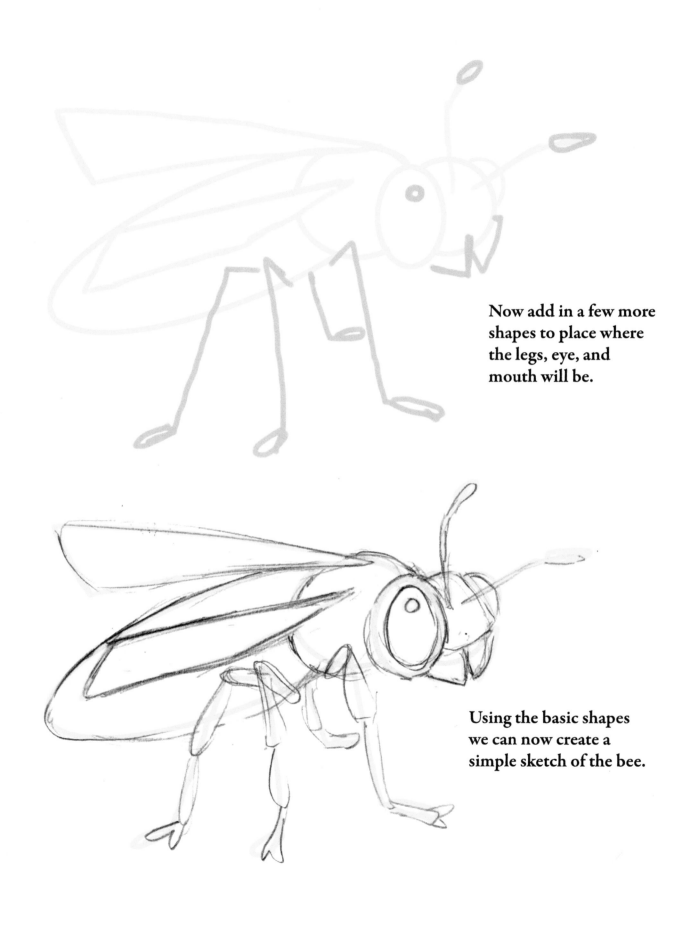

Now add in a few more shapes to place where the legs, eye, and mouth will be.

Using the basic shapes we can now create a simple sketch of the bee.

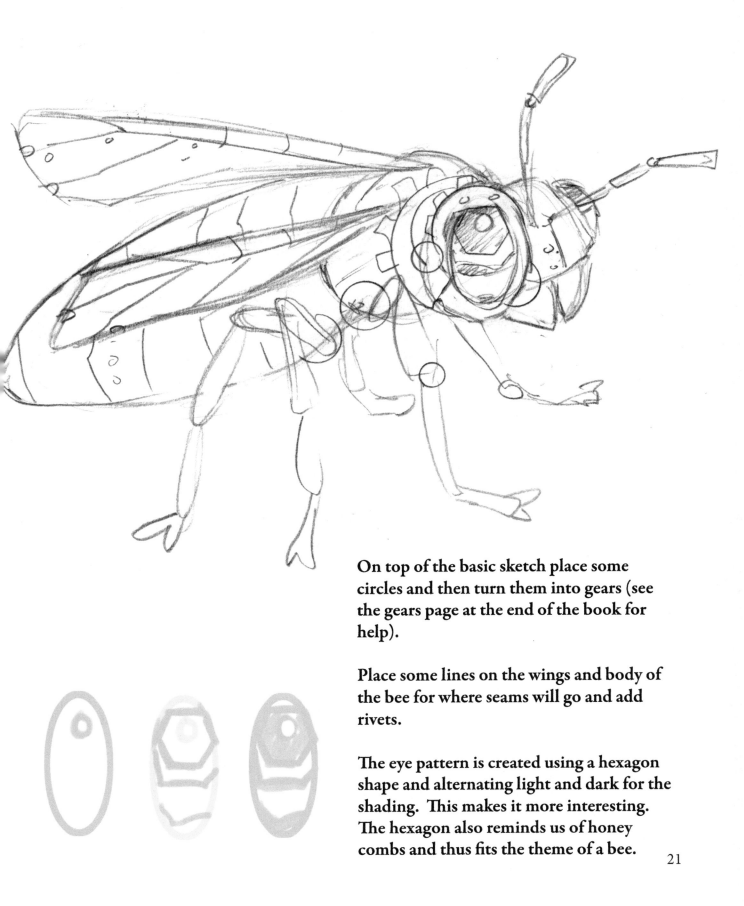

On top of the basic sketch place some circles and then turn them into gears (see the gears page at the end of the book for help).

Place some lines on the wings and body of the bee for where seams will go and add rivets.

The eye pattern is created using a hexagon shape and alternating light and dark for the shading. This makes it more interesting. The hexagon also reminds us of honey combs and thus fits the theme of a bee.

Now you can start "inking" your drawing! To begin just trace over your pencil line carefully with a fine pen. Make sure your ink is fully dry and then erase the pencil. You will have a basic ink drawing like this one:

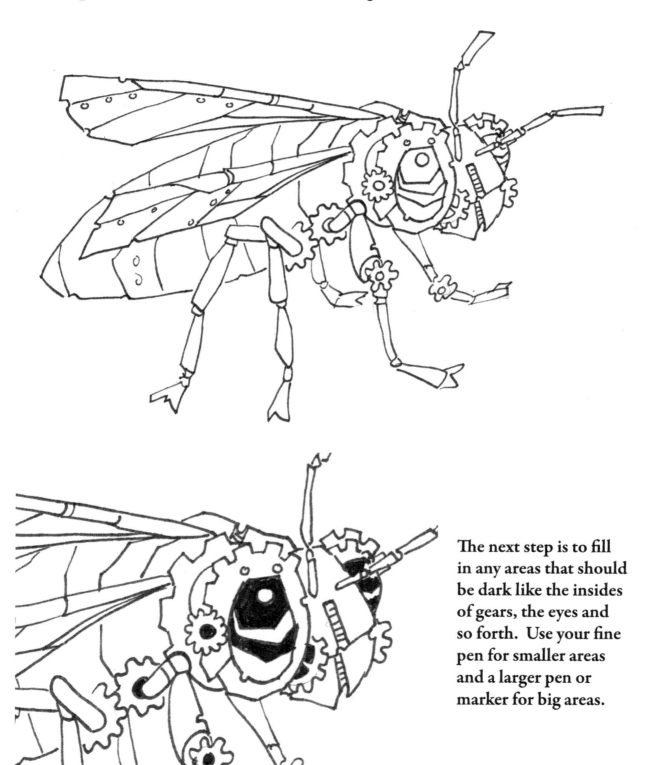

The next step is to fill in any areas that should be dark like the insides of gears, the eyes and so forth. Use your fine pen for smaller areas and a larger pen or marker for big areas.

Here is my finished bee drawing! I made the outline around the bee thicker, but left details thinner and lighter. You can use a fine pen to thicken the lines or a larger pen depending on the size of your drawing.

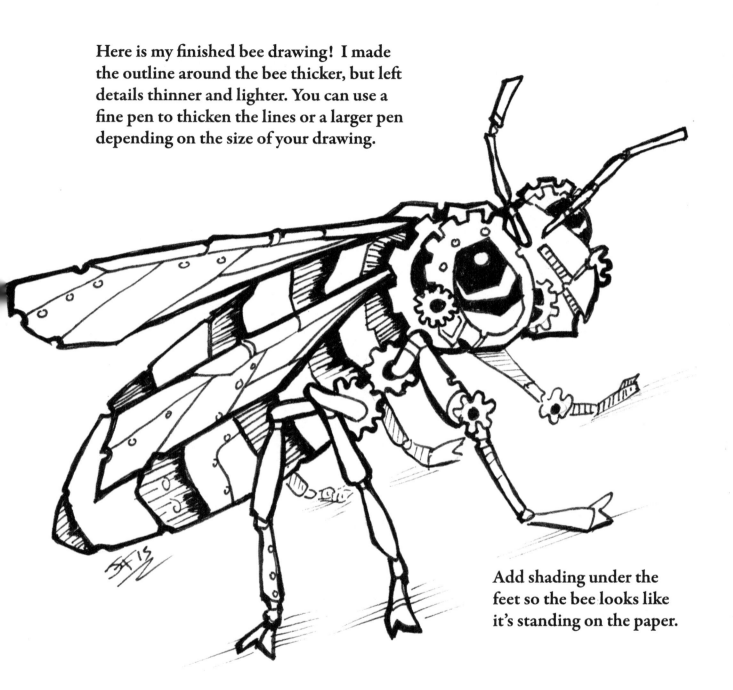

Add shading under the feet so the bee looks like it's standing on the paper.

To suggest the patterning of a bee you can add some darker shading to the "striped" area on the back along with some hatching (see the next page for more on shading).

Shading with Pen

HATCHING is a series of lines in a row that make an area darker, but not completely black. The closer together the lines are the darker an area will look.

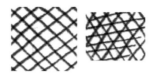

CROSS HATCHING is adding additional hatching going in another direction. This can create a variety of patterns.

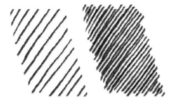

STIPPLING is where you tap the pen to create dots. The closer together the dots, the darker the shading. This creates softer shading and can be good for making metal look old.

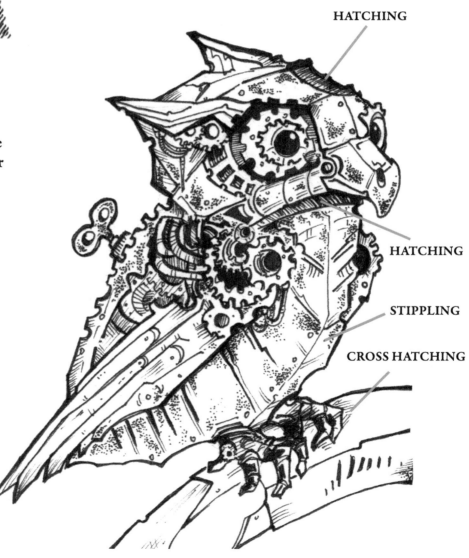

HATCHING

HATCHING

STIPPLING

CROSS HATCHING

Prawn
Drawing with Pencil and Pen

Let's draw a clockwork prawn (a prawn is basically a really BIG shrimp).

Start with an oval for the head, a circle for the eye, and a curved line to place the body.

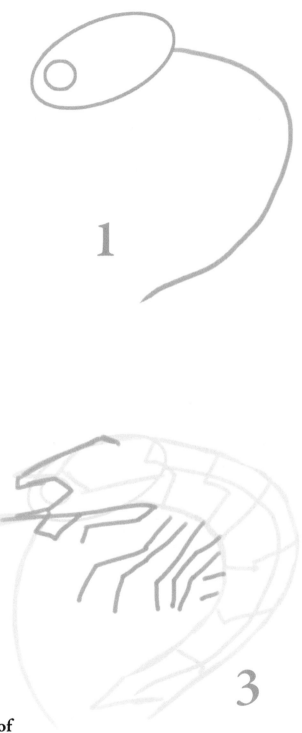

Next we can draw in the shape of the body (around the curved line). Break the body shape up with little zig zag lines and add a few more shapes to the head.

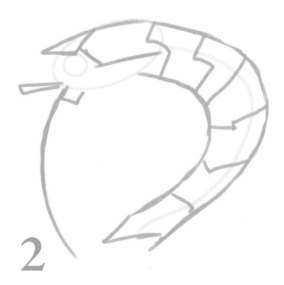

Next draw in the rest of the face shape and place lines for all the little legs.

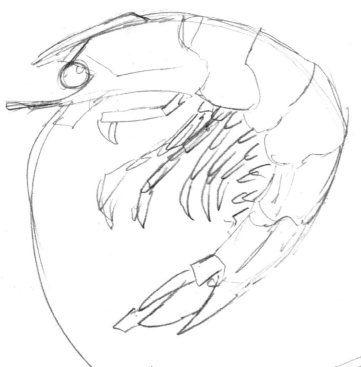

On the left is a sketch drawn using the shapes from the last page.

Note: Animals with segmented shells and legs are very easy to translate into mechanical clockwork. Insects and animals like this prawn can be great for ideas even if you are drawing another kind of creature (like a dragon).

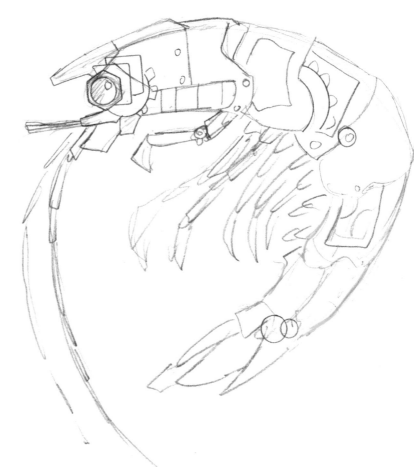

At the right is the drawing with clockwork parts added:

- Circle and square shapes around the eye.

- Rivets (or bolts) along some of the edges.

- A few "cut away" sections to show gears inside.

- More gears on the tail where it joins onto the body.

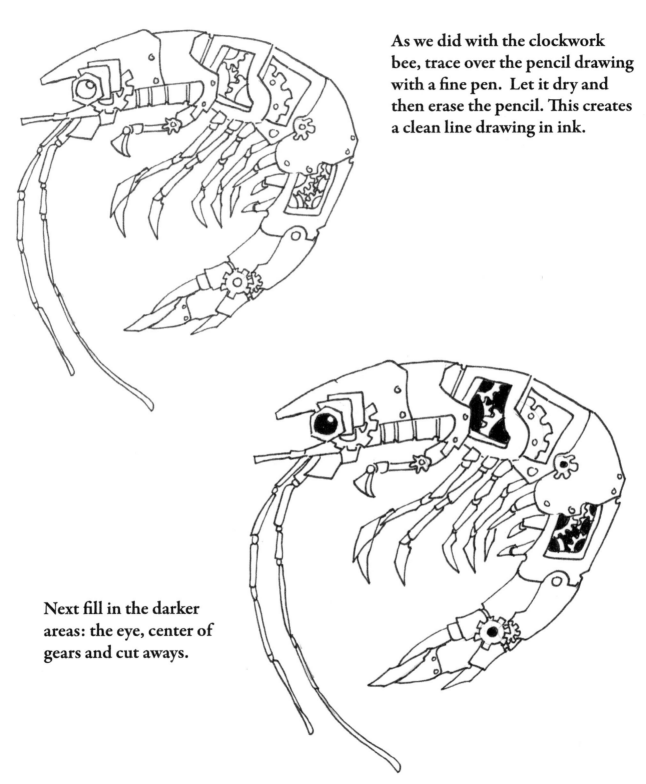

As we did with the clockwork bee, trace over the pencil drawing with a fine pen. Let it dry and then erase the pencil. This creates a clean line drawing in ink.

Next fill in the darker areas: the eye, center of gears and cut aways.

To finish up the prawn make the outline thicker
and add shading: Hatching on parts of the tail and
the lower part of the face. Stippling is applied to
the shell.

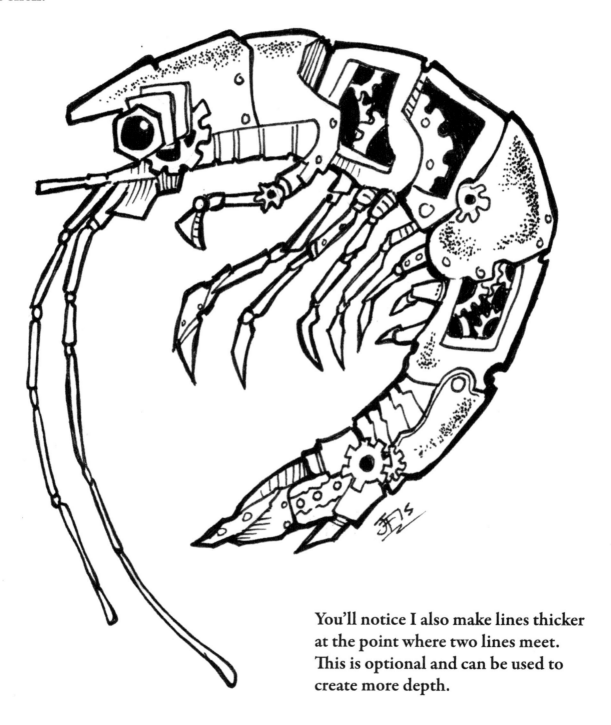

You'll notice I also make lines thicker
at the point where two lines meet.
This is optional and can be used to
create more depth.

Squirrel
Drawing with Pencil and Pen

Now for a more detailed creature! Start the squirrel with a few circles, ovals and lines.

Next add the limbs, tail, and break up the shapes for the face. It's starting to look like as squirrel!

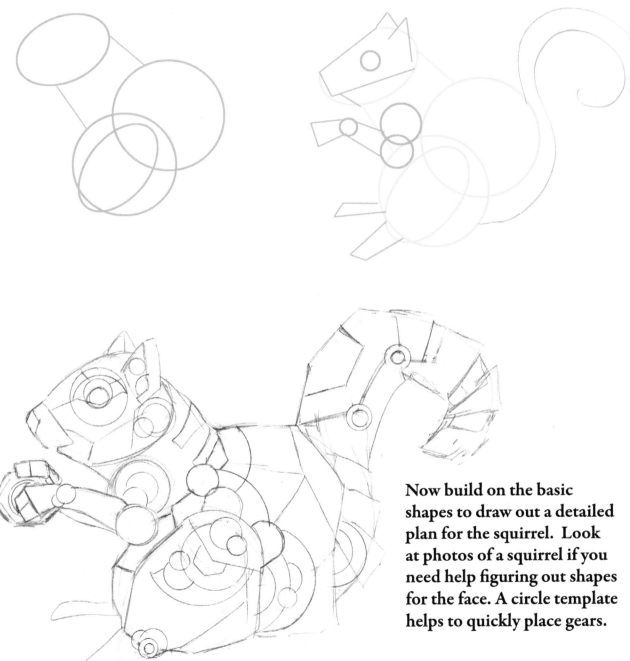

Now build on the basic shapes to draw out a detailed plan for the squirrel. Look at photos of a squirrel if you need help figuring out shapes for the face. A circle template helps to quickly place gears.

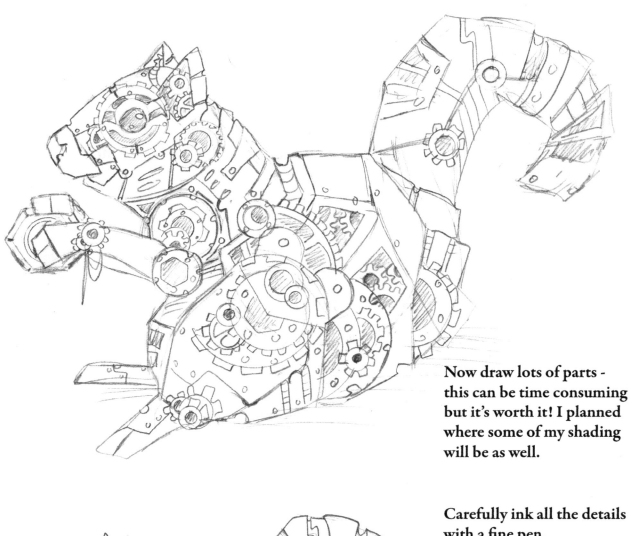

Now draw lots of parts - this can be time consuming but it's worth it! I planned where some of my shading will be as well.

Carefully ink all the details with a fine pen.

If you already roughed in some shading it's a good idea to fill in those areas and let them dry BEFORE erasing the pencil drawing.

Place hatching to create shadows and make important areas (like the eye) stand out.

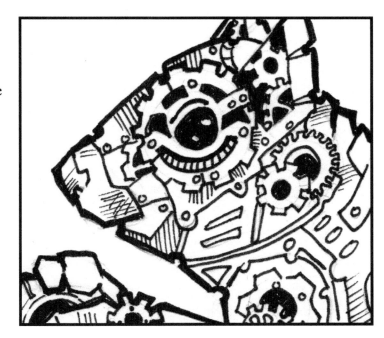

Here's the finished squirrel! As you can see many of the inking techniques discussed previously are used:

Thicker outline around the outside of the body!

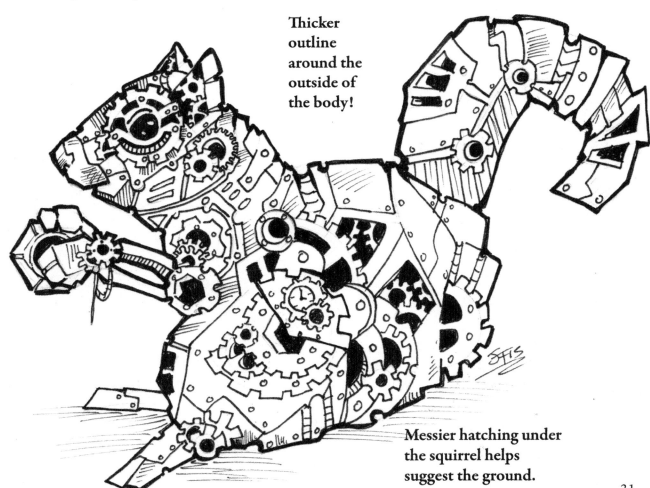

Messier hatching under the squirrel helps suggest the ground.

Goat
Drawing with Pencil and Pen

Are you getting the hang of figuring out basic shapes yet? Let's try something with four legs next!

Start with two circles around the same size for the body and build the rest of the shapes from there.

The basic shapes used for a goat are similar to those that you might use for a horse, unicorn etc.

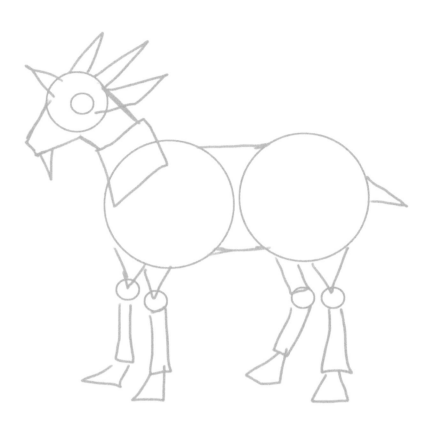

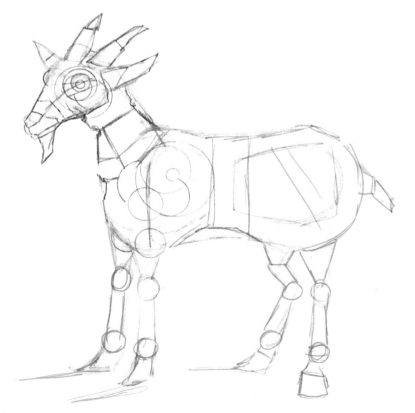

Here's the beginning sketch with a few ideas for the clockwork started.

Remember not to cover every inch of your creature in gears. Leave some open, empty areas that allow the eyes to "rest".

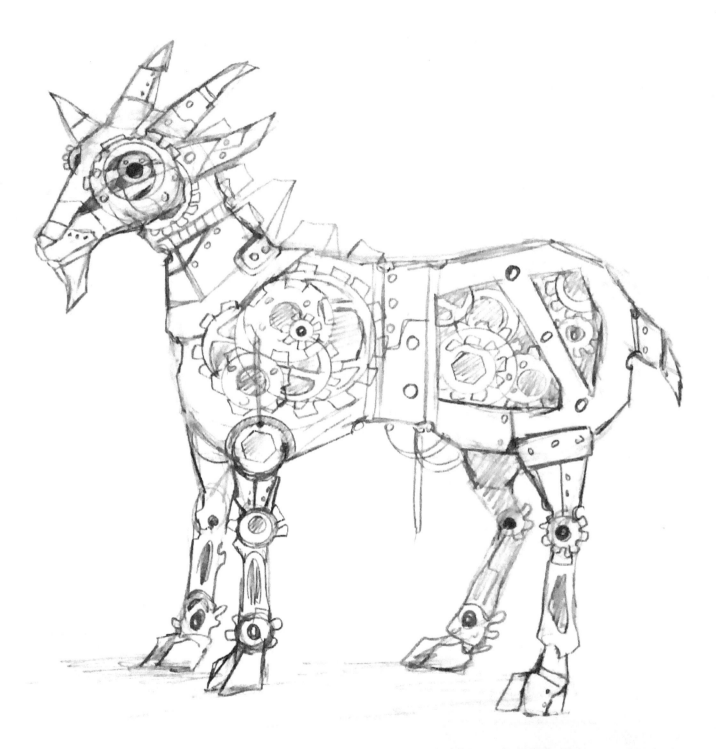

Now move onto sketching the details. For my goat I used lots of overlapping gears and added cut away sections. The darker cut away sections on the face will help balance out the darker areas on the body. When looking at a picture dark reads as "heavier" than light to the human eye.

Now on to inking!

If you've been reading the book in
order you know the drill by now:
Trace over your lines with a fine pen.

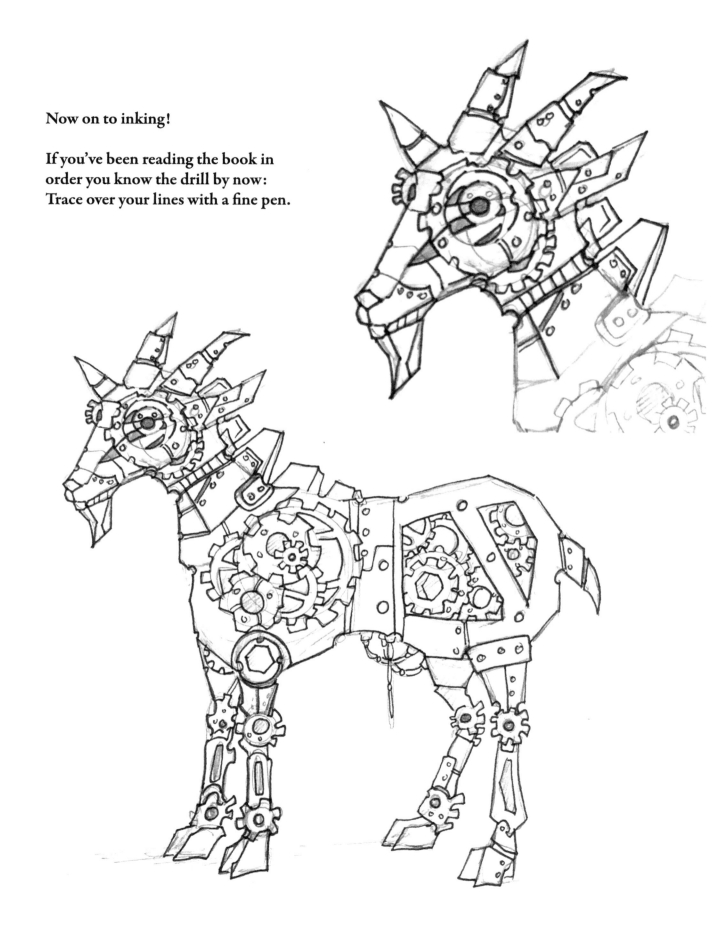

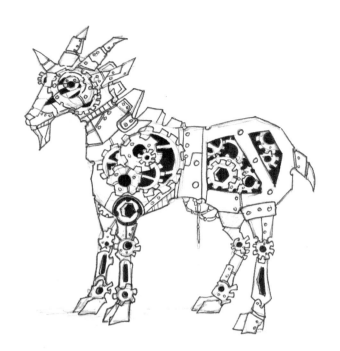

After filling in the dark areas and being sure the ink is fully dry you can erase the pencil drawing.

I find kneaded erasers work the best for quickly erasing pencil without damaging the paper.

You can see in the example on the right I've added hatching to the ground area, the back leg, under the body, along the back and so forth.

This starts to make the goat have more dimension to it.

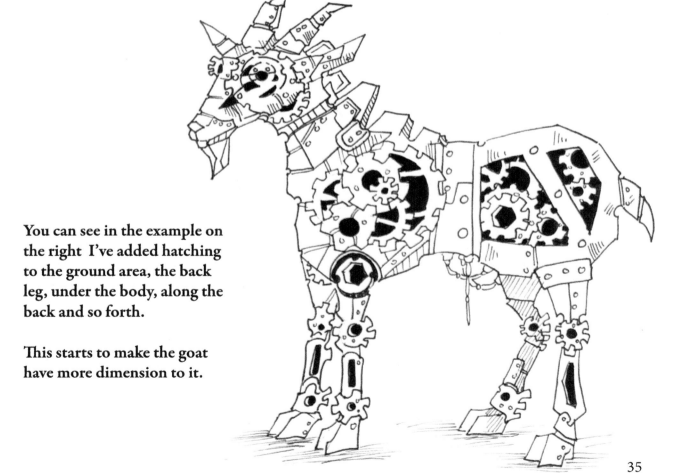

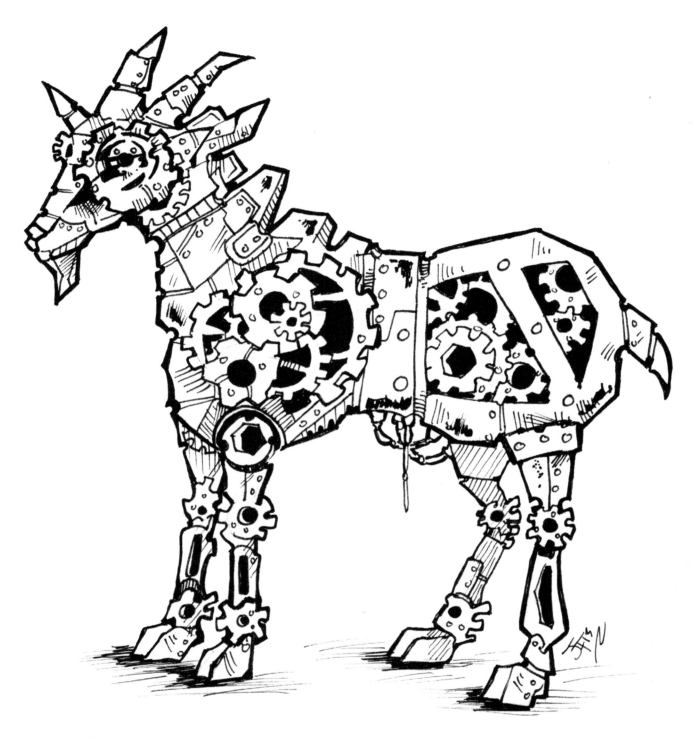

On the finished drawing you can see I applied many of the inking techniques
covered in previous examples: I added a lot more hatching to the face and body and
I made the outline of the goat thicker. I also really wanted so make the goat pop out
so I added some more solid shadows along his belly and under his feet.

Dragon I
Drawing with Pencil and Pen

Let's draw a clockwork dragon (about time)! Start off with some overlapping ovals for the body, then place the neck, head and tail.

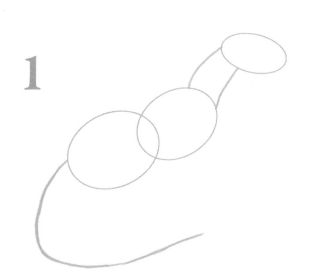

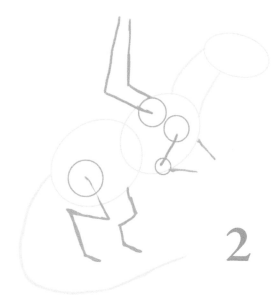

Next place the limbs. Note that at this point the same basic shapes work well for a dinosaur (minus the wings).

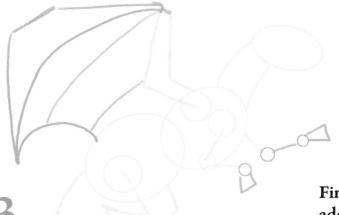

Finish out the basic shapes by adding the rest of the wings and claws. Now we have a great blueprint for our dragon!

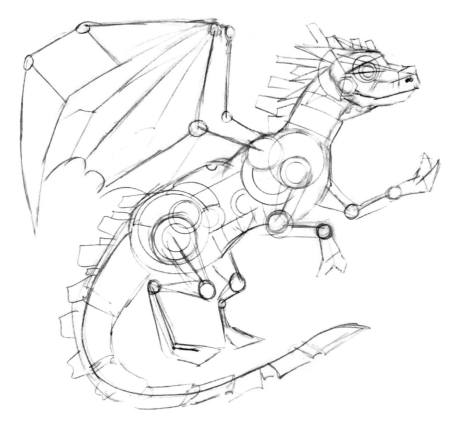

You know the drill! Use the basic shapes and plan out where the clockwork will go.

The exact shape of the face including the eyes and mouth is up to you. These will give your dragon his expression. I'm going to give mine an angry looking eye with a smiling mouth. This will suggest he's up to something sneaky.

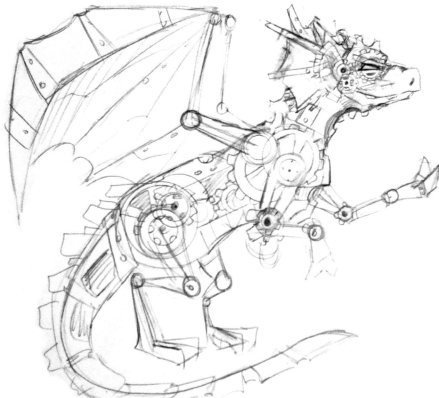

Move on to adding all the detail for the parts!

Remember there are a bunch of ideas for parts at the back of this book.

For example I used the "Wings & Fins" page to design his wing and add a fin on the side of his head.

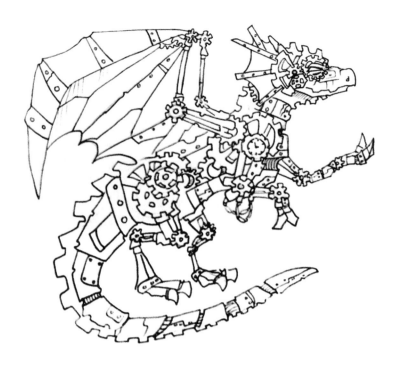

Now ink the drawing with a fine pen.

When working on really detailed creatures try drawing them larger (using bigger paper).

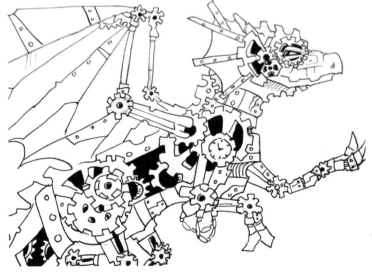

Once the basic inking is done and the pencil erased, fill the darker areas in.

Then start to make some lines thicker and add in shading. I put nice dark shadows under the eye to make it stand out.

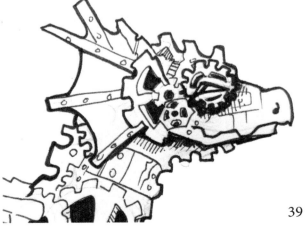

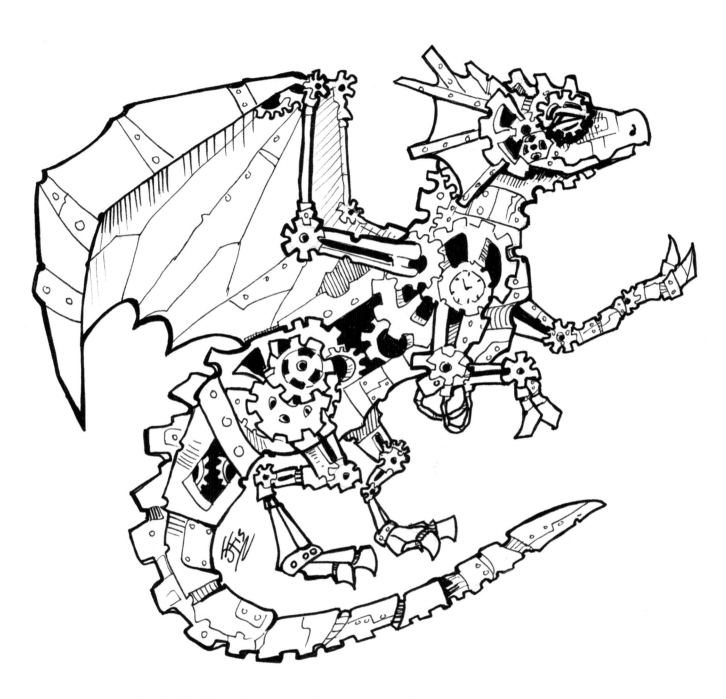

Here's the finished dragon! Note the use of hatching on the inside of the wing and a number of other spots. I often create small hatched shapes to break up areas that might seem boring like the tail.

Inking with a Brush

Inking with a brush is a great alternative to using a pen. I suggest testing out ink on the type of paper you plan to draw on to be sure it is thick enough before you start drawing. This example was done on watercolor paper.

Once you have a pencil sketch, use a small brush and begin to apply ink. The size brush you should use depends on the size of your drawing and level of detail. I'd suggest a size zero or smaller.

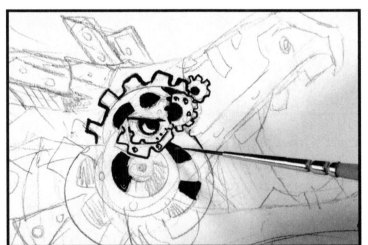

Inking with a small brush can take some practice, but it is similar to using a pen, and in many ways easier (it's much faster to fill in solid black areas for example).

Be sure to work in a way where you won't be smudging your ink!

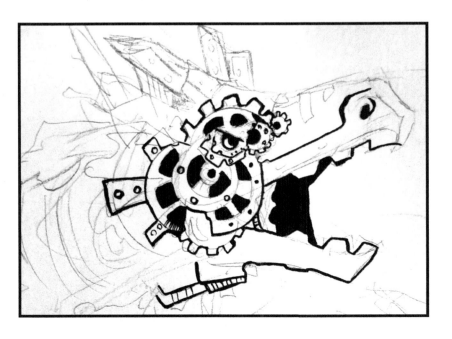

I will wait until the lower part of the face is completely dry before I work on the top of his head to prevent smudging. If you're not sure how long your ink takes to dry do some tests on scrap paper to see.

41

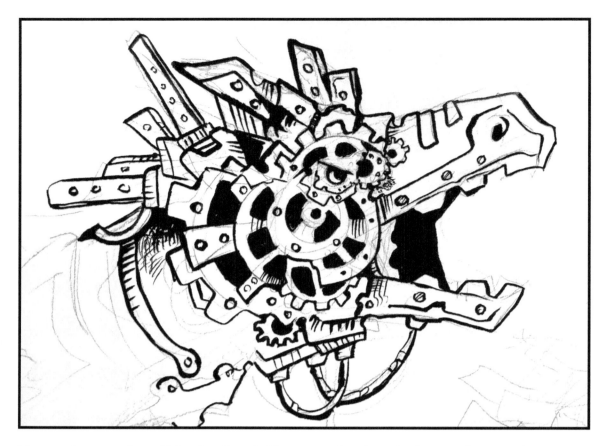

Your inking style will look a bit different with a brush than it does with a pen. Mine tends to be more rounded and smooth. Hatching and cross hatching will also look different so test out techniques on scrap paper first!

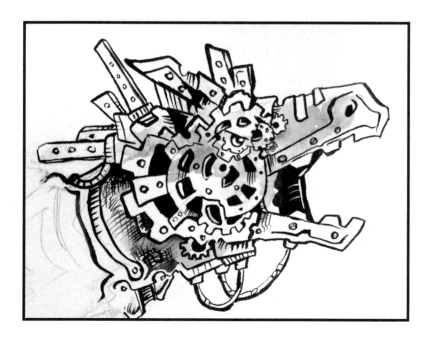

You can mix the ink with water to make it lighter and add shading if you want to. This is a great way to use more blended shading like you would with pencil or watercolor.

Remember you can always use both a brush AND a pen together.

Raccoon
Pencil, Pen, & Colored Pencils

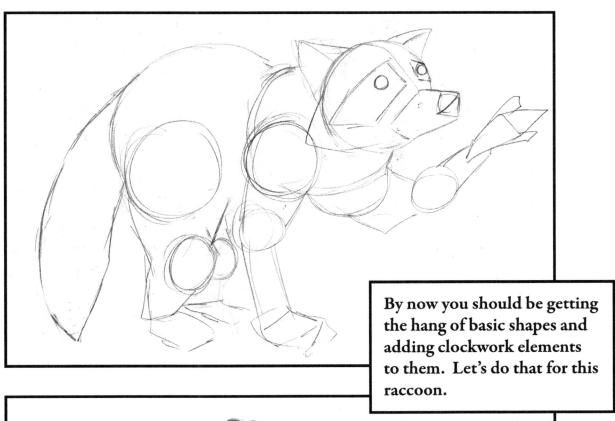

By now you should be getting the hang of basic shapes and adding clockwork elements to them. Let's do that for this raccoon.

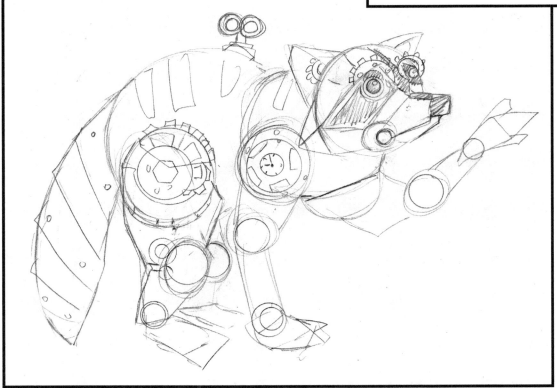

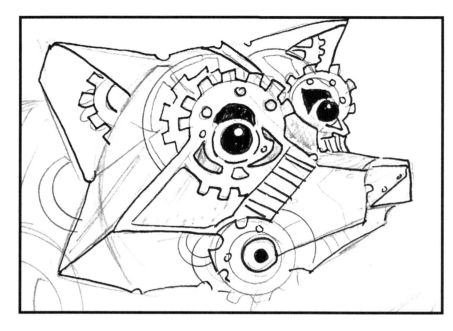

Now ink the drawing....

Notice that I've created large solid black areas on the face to suggest the markings (i.e. mask pattern) that raccoons have.

These types of details are key in communicating that it's a specific type of animal.

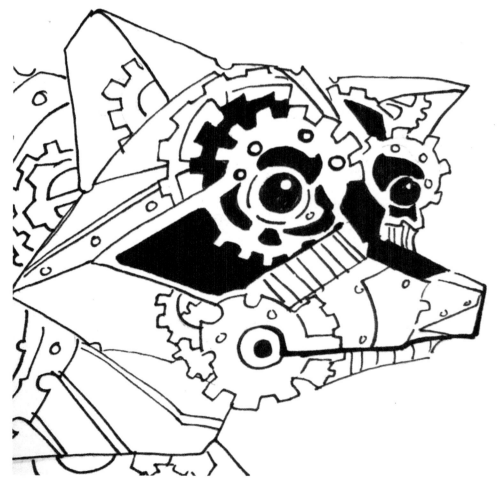

Just like the earlier examples, make some lines thicker and add shading finish the ink drawing.

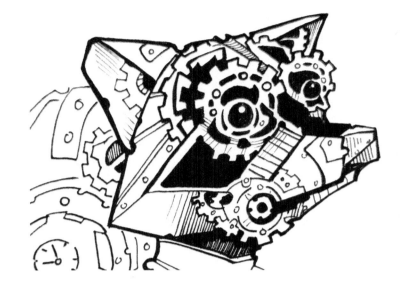

On the Raccoon I've used a lot of hatching to show depth. This is most noticeable under the chin.

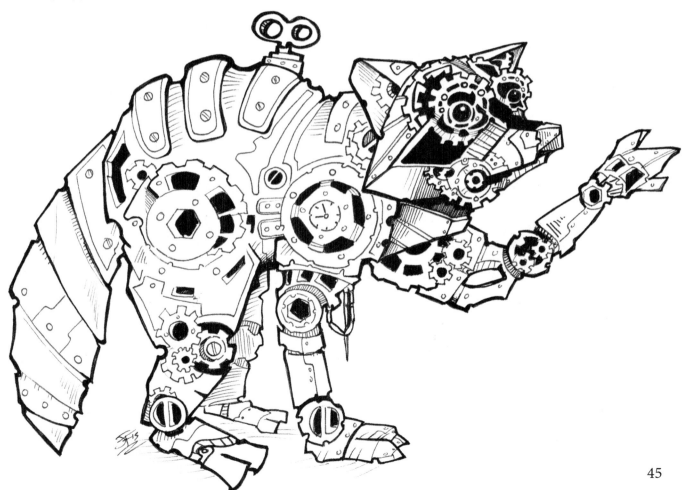

Now we're ready to use some colored pencils over our ink drawing. Colored pencils work fine on card stock. You can also experiment with paper specially made for colored pencil.

To color this picture I used the materials shown at the left including six Prisamacolor colored pencils. I tested the colors out first to pick them and highly recommend you always test your colors first too!

To start with place the shadows. I used a very dark purple called *Black Grape* for this. Press gently and move your pencil with small circling motions to apply an even layer of color.

Next add some brown (I used *Sepia*). You want to cover your shadows and extend a little beyond them.

Now we repeat the layering process and add in some orange! I used *Pumpkin Orange* on my raccoon. Be careful to leave plenty of white (the paper).

TIP: Drawing with colored pencils can sometimes create some colored dust and "burrs". Use a clean brush to dust it off so you don't smudge it into your drawing. I have a retractable makeup brush (unused) just for this purpose.

Here's where it gets exciting! Adding a bright yellow to really make the metal come to life! I picked *Canary Yellow.*

You want to press just a little bit harder and layer the yellow over all the color we already did and SOME of the white of the paper.

Leave just a little white peaking through in the most shiny areas.

47

Now we've used 4 of the 6 colors! Next create darker shadows in areas like the inside of the ear.

To do this layer on more of the *Pumpkin Orange* and *Black Grape,* plus a little bit of very dark red. I used *Tuscan Red*.

Here's the raccoon with the face colored.

I've also added just some hints of a blue-green color to a few spots on the metal. I did this using *Aquamarine*.

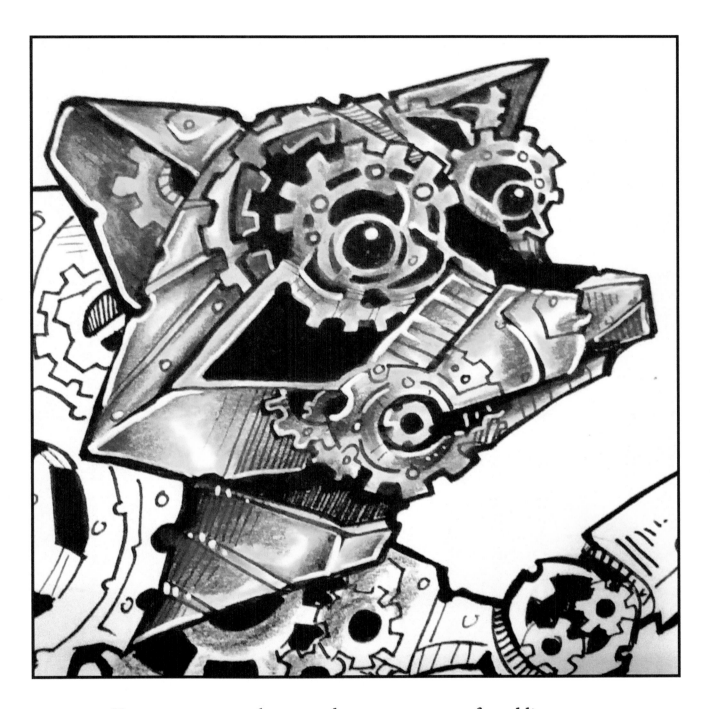

You may want to make some edges pop out more after adding color. White ink with a very small brush is the best way to do this. Use the brush to line a few edges with the white to make your clockwork have more dimension.

Here's the finished raccoon. I repeated the same layering techniques over the rest of the body.

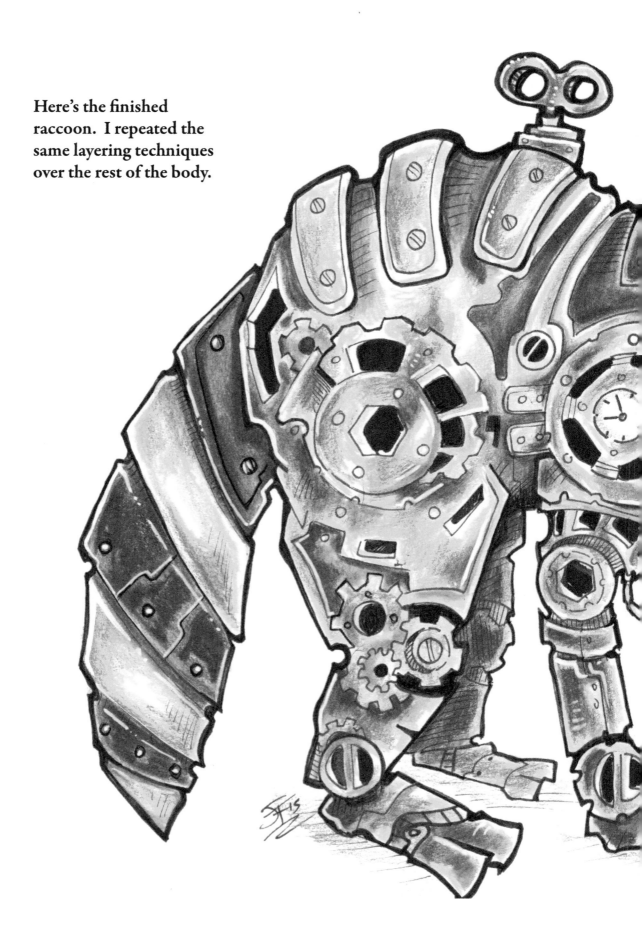

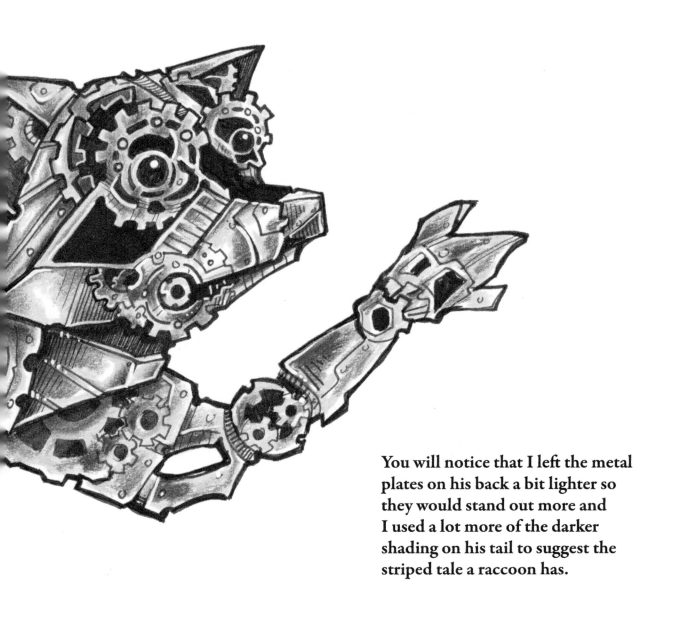

You will notice that I left the metal plates on his back a bit lighter so they would stand out more and I used a lot more of the darker shading on his tail to suggest the striped tale a raccoon has.

The colors used in this example work great for shiny golden clockwork. For other types of metals experiment with different colors layered over each other on a test paper first. It's a good idea to write down the color names you use for different projects too, in case you need them later on.

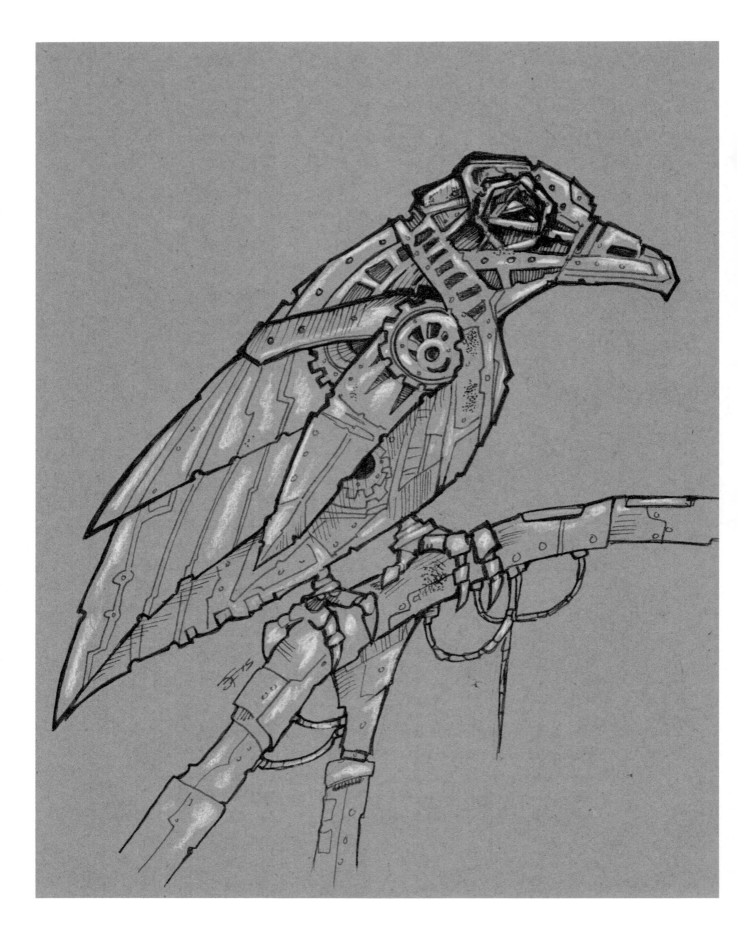

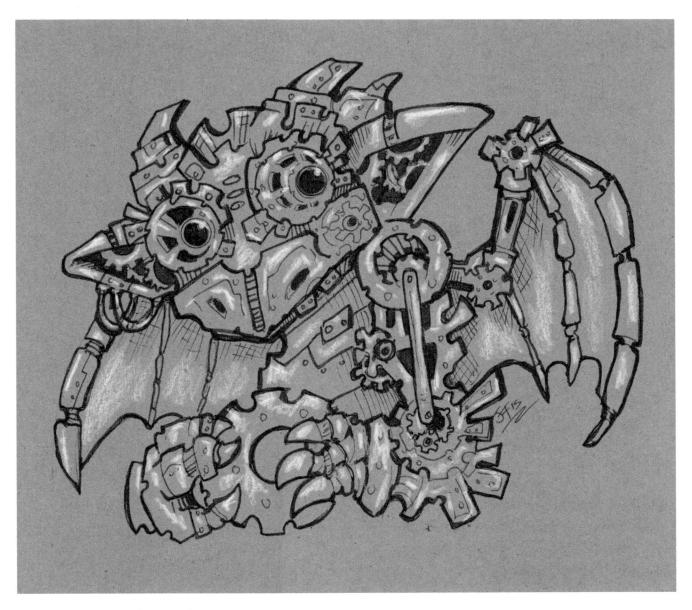

Using Colored Paper

Colored cardstock or colored art papers (see what your art store has) can add another dimension to your art! Drawing and inking on this is much the same as normal paper, but you can also add white highlights that will really make your drawings pop!

There are two methods for adding highlights: One is to use white ink (with a brush) which will make very crisp, bright white highlights. The other us to use a white colored pencil which is a bit softer.

Kraken
Watercolor over Ink

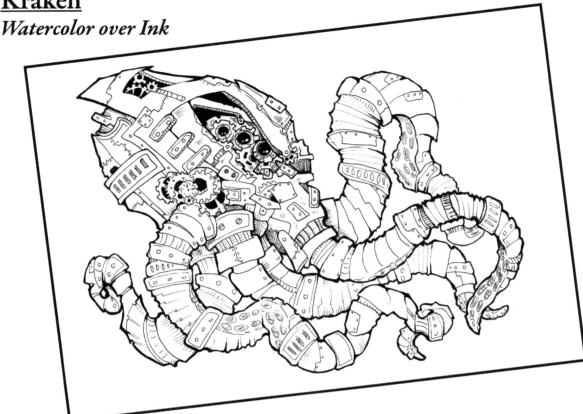

Now we're going to look at coloring an ink drawing using watercolor. First be sure your ink drawing is drawn with waterproof ink on watercolor safe paper.

Next use a scrap of the same paper to test out colors and plan which ones to use on your painting. Paint colors may vary even if paints have the same name so it's always a good idea to test your colors first.

For this painting I picked a brown, blue, orange and yellow and tested them out. These will work well for creating a rusty creature that has been in the water a long time.

Start painting with a medium brush and a fairly light shade of brown. It can take a little while to get the feel for how much paint and water to use so you may need to use a test paper to check your colors.

If the paper is WET and you add paint it will blend with the colors already there.

If the paper is DRY and you add paint it won't blend much.

This creature is old and rusty so we want the colors to bleed into each other. While the brown is still wet add some yellow.

Then get a SMALL amount of blue on your brush and "touch" it to a few wet spots very lightly .

If you use too many colors you can end up with mud! That's why testing out colors and using a limited number of colors is a good idea.

Continuing this process and working in sections, keep adding color. Keep in mind that colors usually dry lighter, but it's much easier to make a painting darker than lighter so err on the lighter side.

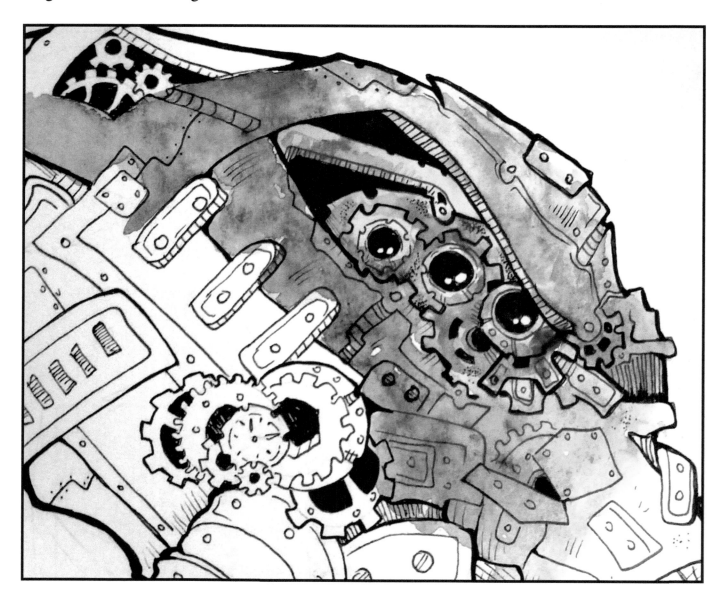

To make it look really rusty add in touches of some red-ish orange and teal blue (the blue looks more green in spots because it's mixing with the yellow and brown). Touching in color works best when the paper is damp, but not super wet. Then you lightly "touch" your brush to the paper and let the color spread out on its own.

Once I've applied color to the whole creature and let it dry it looks like this:

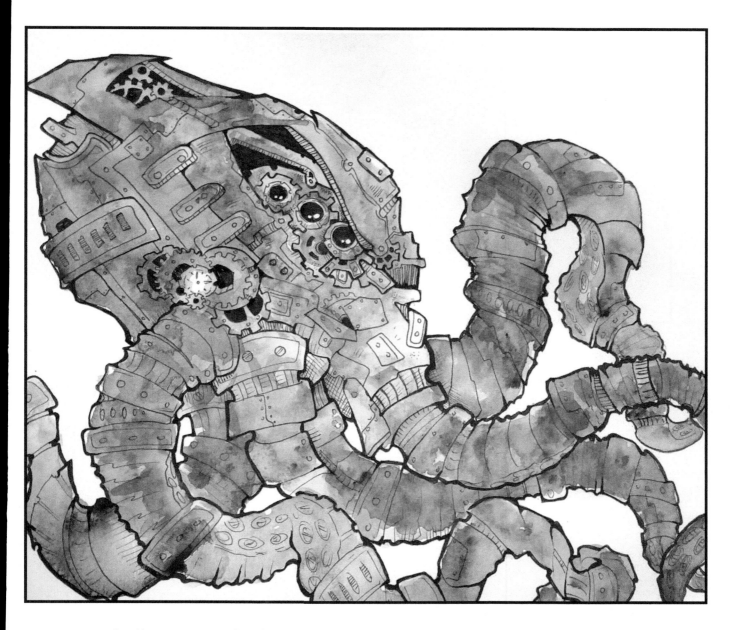

With allowing time for drying it takes around an hour to reach this stage (on an 11x15 inch painting). You need to be sure it is fully dry before adding more details. If you have trouble being patient try having multiple paintings or drawings started. That way you can work on inking or painting another picture while this one is drying.

Now switch to a smaller brush and paint in details! To add darker rust use more paint and less water to get a dark red-ish brown. I find tapping a small round brush a bit randomly makes great rust patterns. You want to leave plenty of the lighter colors showing though.

Rust and water stains are most likely to happen around joints so add darker stains where two pieces of metal meet.

Another way you can create texture is to use sponges to apply paint. These will result in different textures. As always test on a scrap paper before you try it on your painting!

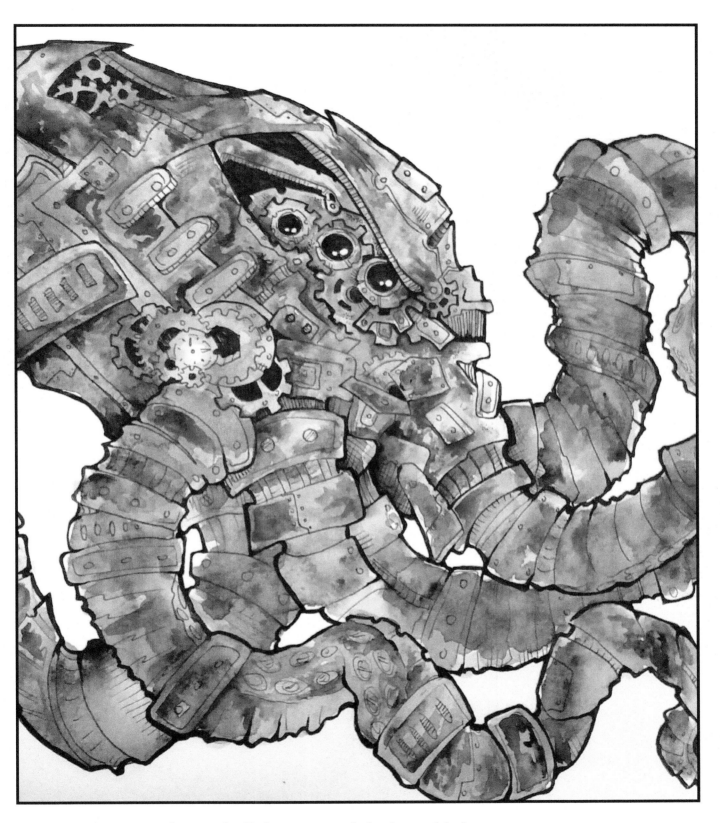

Here's Mr. Kraken with all the stains and shading added.
Now all we have left to do is add highlights!

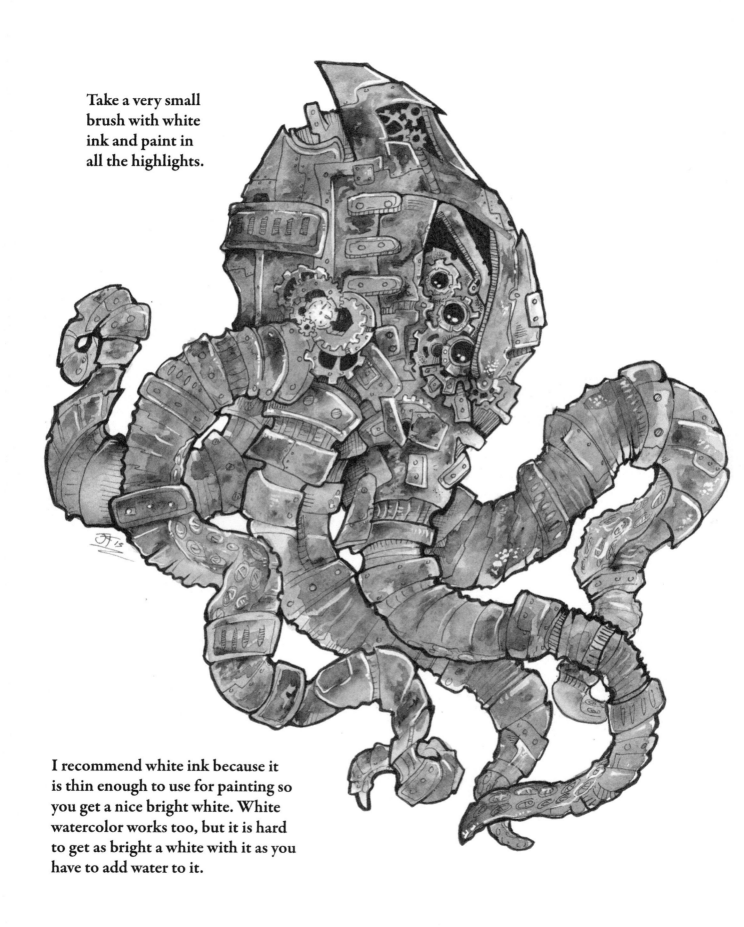

Take a very small
brush with white
ink and paint in
all the highlights.

I recommend white ink because it
is thin enough to use for painting so
you get a nice bright white. White
watercolor works too, but it is hard
to get as bright a white with it as you
have to add water to it.

Painting Glowing Things

To paint a "glowing" area on a creature like this clockwork golem, start with a light color and paint the inside of the area.

Next use another light color that goes well with your first color (I'm using greens and blues for my glow) and add a light amount around the area.

Now paint in the rest of the clockwork (some of this will overlap what you already painted).

Lastly use white ink to outline the glowing area and add some highlights inside the glowing object. Water down a little of the white to paint the surrounding glow brighter.

If the glow looks too white wait until the ink has fully dried and then use a very small amount of paint in a light color over it (I used more of green).

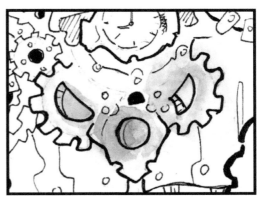

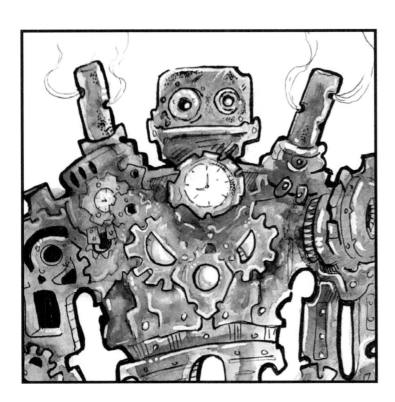

Painting Metal

Painting metal in watercolor uses a lot more colors than you might expect. At the right are a number of different color combinations you can use for metals (and you may want to try out some of your own).

If you are using a cool color such as a blue for shadows always start with that. Then layer in your other colors one at a time ending with the warmer colors (yellows, golds etc).

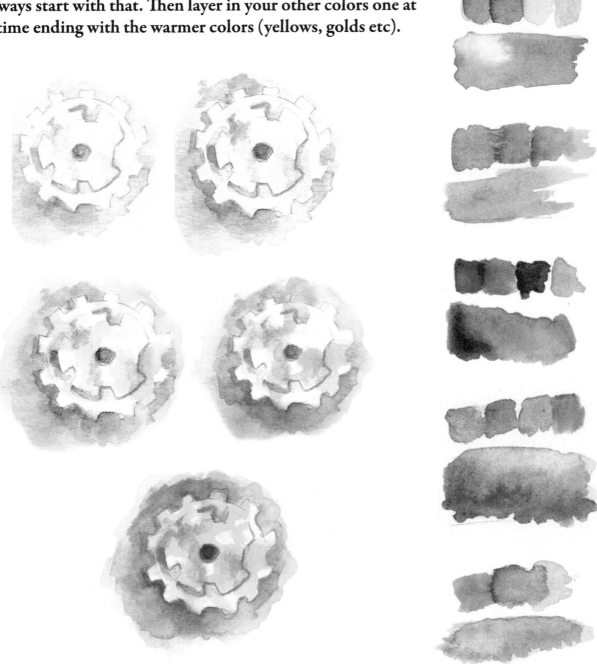

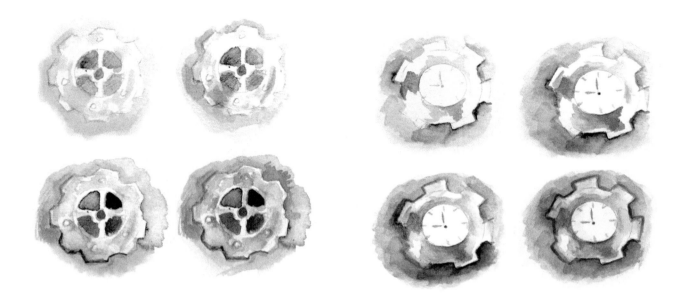

Really old items might rust, tarnish or oxidize (which causes metal to usually turn blue or green).

For an oxidized effect: start with the normal color of the metal and then, while it is still wet, touch in just a TINY amount of blue and/or green.

For a rusty look: pick a darker red-ish brown or orange. Then tap in a small amount on edges.

Ladybug
Adding Digital Color to a Pen Drawing

The digital techniques shown in this book are very general and can be accomplished in most painting software. (I'm not including software specific techniques as you can easily find those online or in countless other books).

First scan the drawing and make sure it is adjusted (use "Brightness/Contrast" or "Levels") so you have a crisp black pen drawing with white background.

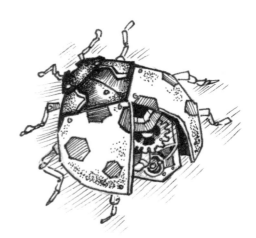

Next use "Hue/Saturation" settings to change the color (sometimes this is also listed as "Colorize" depending on the software) so you have a brown ink drawing.

The next step is to set the ink layer to "Multiply" and create a new layer under it.

Most software has a "Magic Wand" or "Selection" tool you can use to select the white background then "invert" the section so you have just the lady bug selected. This will allow you to fill the lady bug's body in a solid color (do this on your new layer so the color is separate from your drawing).

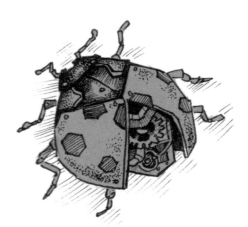

Now "lock" the transparency for your color layer. This means any painting you do on that layer will only appear where you already have paint. Basically it keeps all your coloring inside the lines automatically.

Now you can start coloring! Pick a small brush you like and add some light yellows with just a hint of blue and orange where the shadows will be.

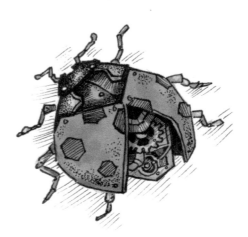

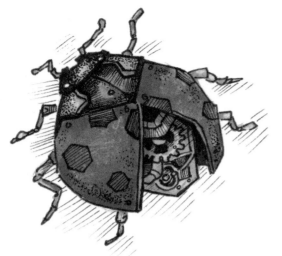

Next continue building the colors adding more yellow and reds. I used a textured chalk-like brush to add the red so some of the brown shows through (suggesting worn paint).

Most painting software has brushes that come with it. You can also search online to find free textured brushes and directions on creating your own custom brushes.

Now add highlights to create "shine" on the metal. You don't need to do a lot of shading because the ink drawing already has it.

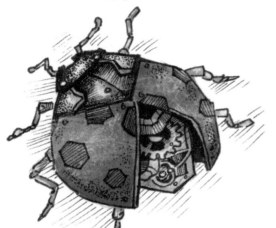

Try using a layer set to "Dodge", "Color Dodge" or "Overlay" to add the highlights.

Now create two final layers:

A shadow layer at the very bottom (under your color layer) to paint in the shadow under the bug.

Also create a highlight layer above your pen drawing. On this layer use a very small brush and some white to pop out the details.

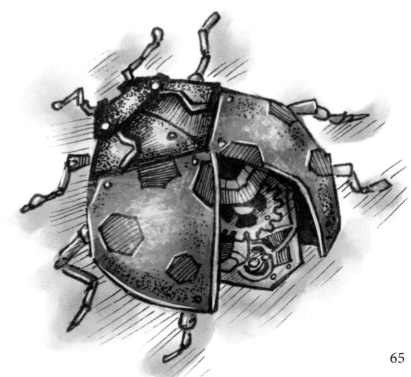

Dragon II
Shaded Pencil Drawing

This example shows how to draw a dragon breathing steam. You can use the same basic shapes to draw one, breathing fire, ice, etc.

To begin use a large letter "A" to place the open mouth (as shown at the right). From the "A" shape add a snaky curve for the neck. You can use the same curve shown here or try other poses by moving these basic shapes around.

Next build on more shapes to create your dragon.

This is accomplished by placing a half circle for the head, thicker neck lines, triangles for horns and so forth.

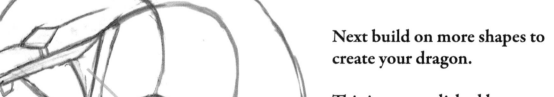

Note how the "A" is divided into smaller shapes to show depth in the mouth. This will help place where the steam will be coming from.

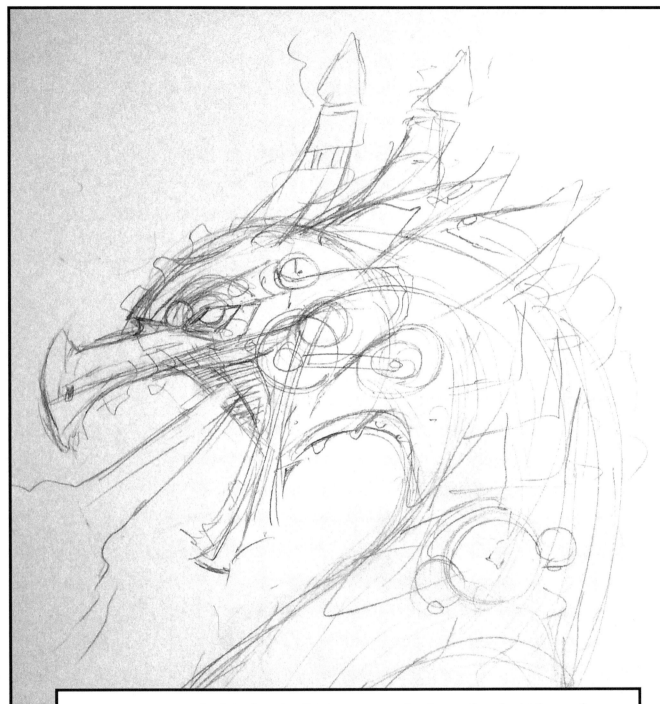

Now create a rough sketch. At this stage you don't need to be tidy or clean, just draw lightly to place where parts will go (gages, gears, vents etc).

When breathing steam (or fire) it will start with a narrower stream and then expand as it leaves the mouth.

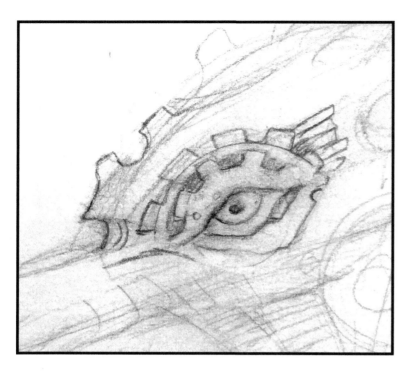

Now you can start drawing the really detailed design elements!

The most detailed area should be the face, especially around the eye as this is the focal point for our drawing (and where the most expression comes from).

You can start adding darker shadows as you add the details, this will help make things pop out. Darker shadows should be placed where elements (like the gears) overlap.

You can soften your drawing by rubbing it gently with a textured napkin or paper towel. This will blend your drawing a bit. Then you can pop areas back out with an eraser.

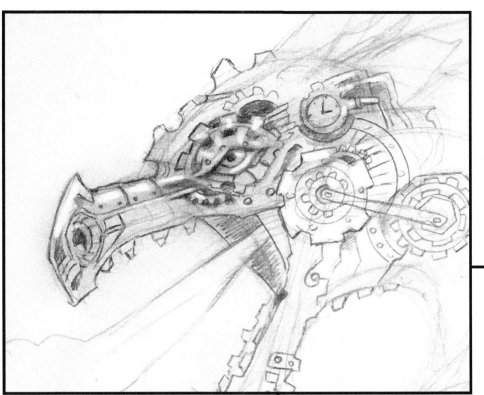

Continue to draw more details, soften them a little with a napkin, and then erase in highlights.

When choosing where to place highlights you may find it helpful to look at metal objects and see how light hits them. Even household items like metal pots or silverware can be useful.

For the steam the dragon is breathing the edges should be kept softer and your erasing should be more gentle. Metal will have sharper, brighter highlights and steam will be softer (like clouds).

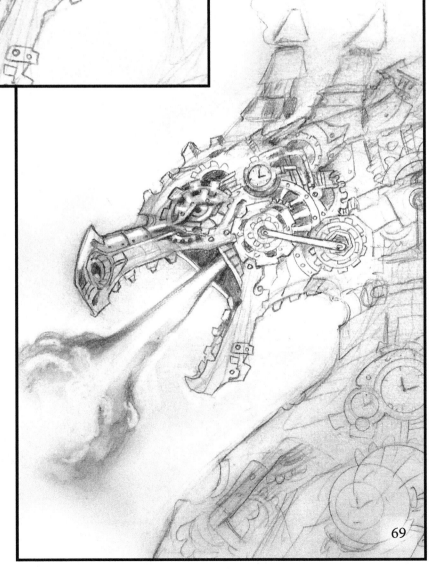

69

Notice how smudging and blending the pencil can go very dark for some areas.

You want this especially dark anywhere you will show steam venting.

Using a small eraser you can then erase to create the steam coming out of the vents.

This should be the last thing you do after other details in an area are done as the steam may need to overlap them. If they look too bright or crisp blend very gently with a napkin, tissue, or cotton swab.

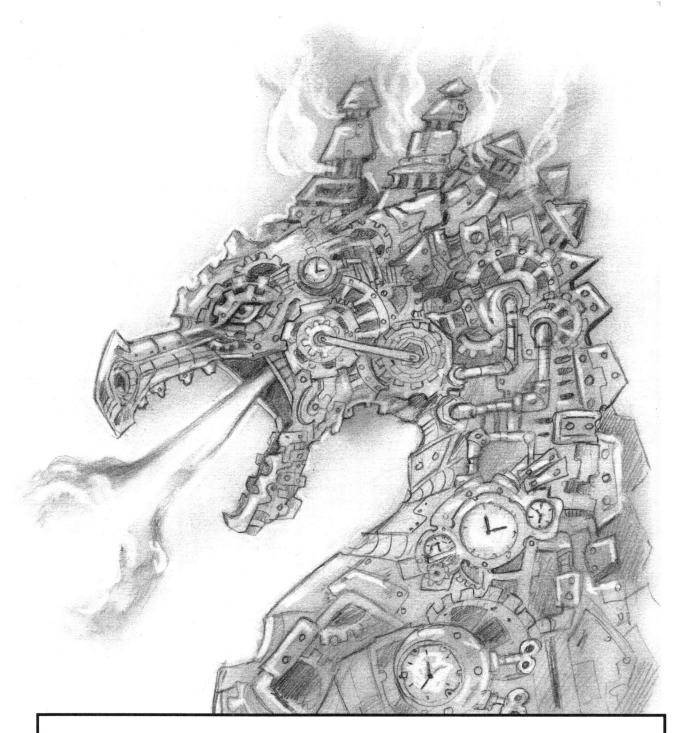

Here is the finished drawing. Note the sharper, darker details drawing attention to the eyes. At this point you can optionally add color with watercolor, colored ink, or digitally (shown on page 75) or simply leave the drawing in black and white.

Here are some other pencil
drawings of dragons
to show more shading
techniques in practice.

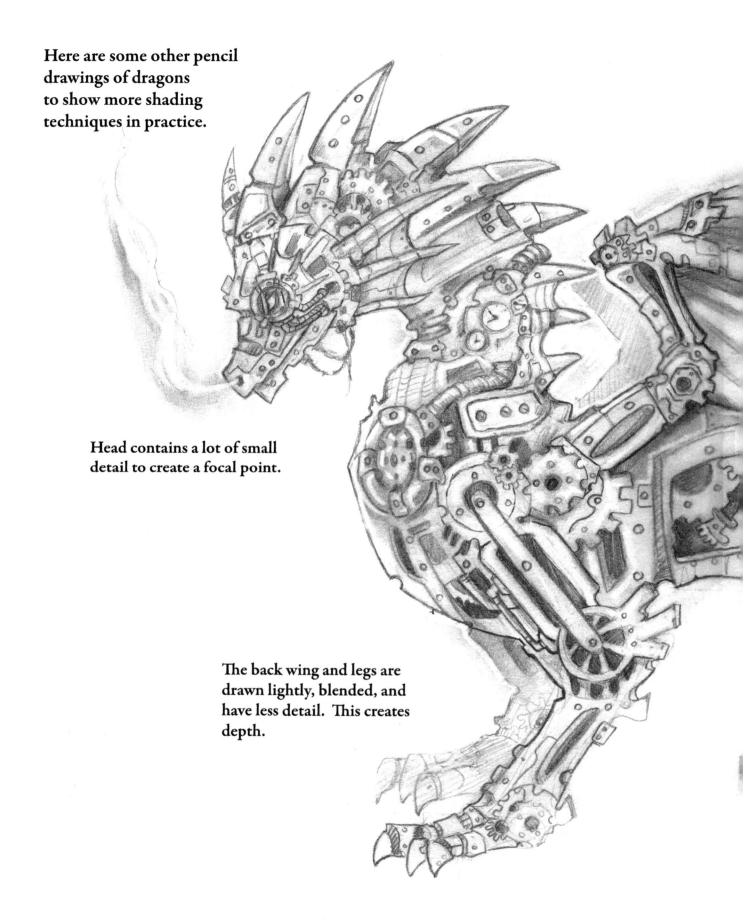

Head contains a lot of small
detail to create a focal point.

The back wing and legs are
drawn lightly, blended, and
have less detail. This creates
depth.

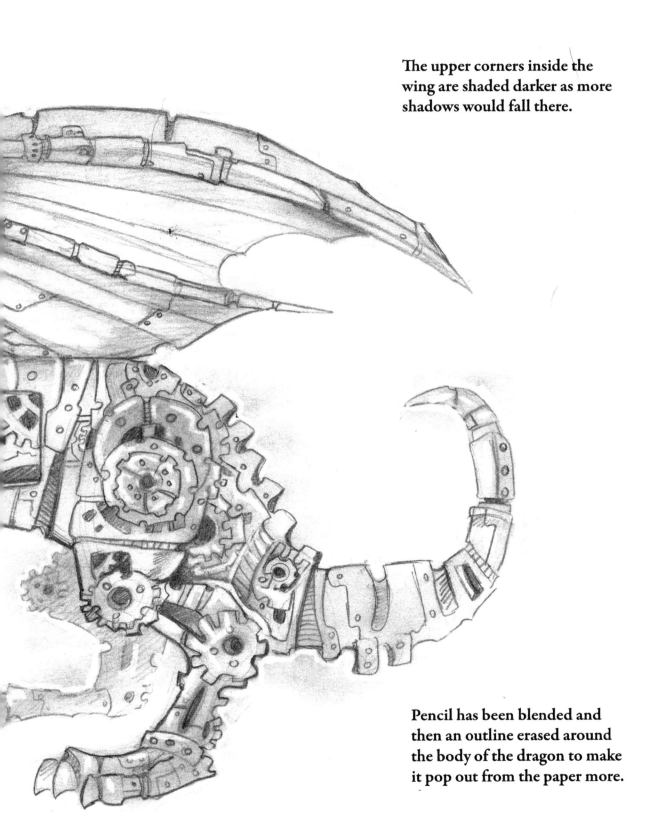

The upper corners inside the
wing are shaded darker as more
shadows would fall there.

Pencil has been blended and
then an outline erased around
the body of the dragon to make
it pop out from the paper more.

Note the darker, more
blended shading used
for the "cut away" areas.

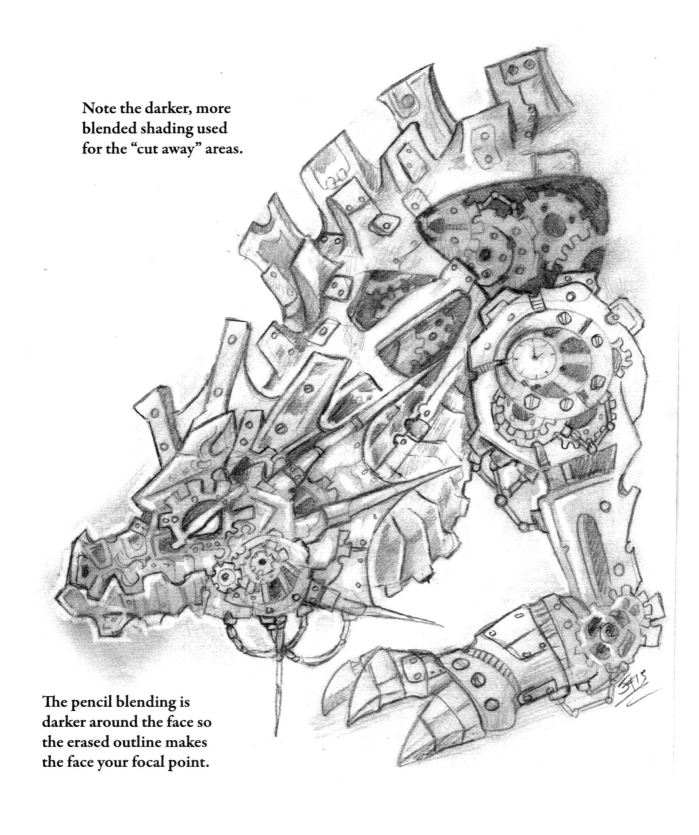

The pencil blending is
darker around the face so
the erased outline makes
the face your focal point.

Now we are going to take a look at adding digital color to our steam dragon pencil drawing!

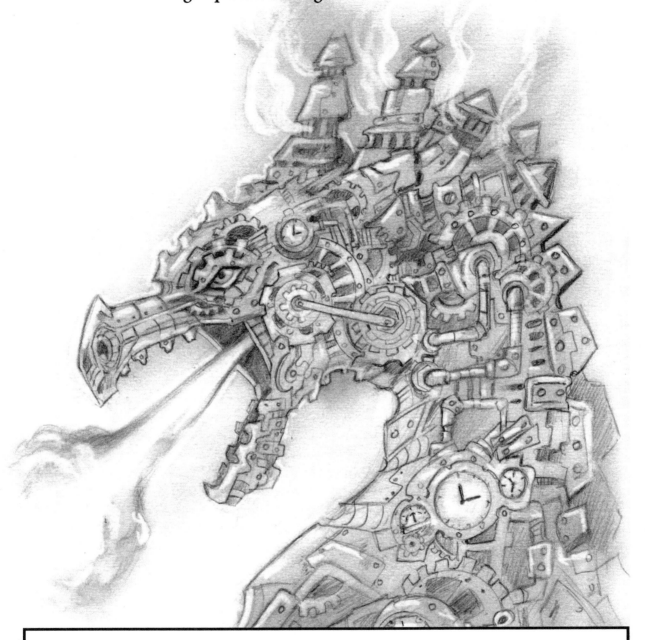

Once you have the pencil drawing scanned, use either a "Hue/Saturation" adjustment or "Colorize" to change the color to brown. This will make it look more natural as we add the color. Set your pencil drawing layer to "Multiply".

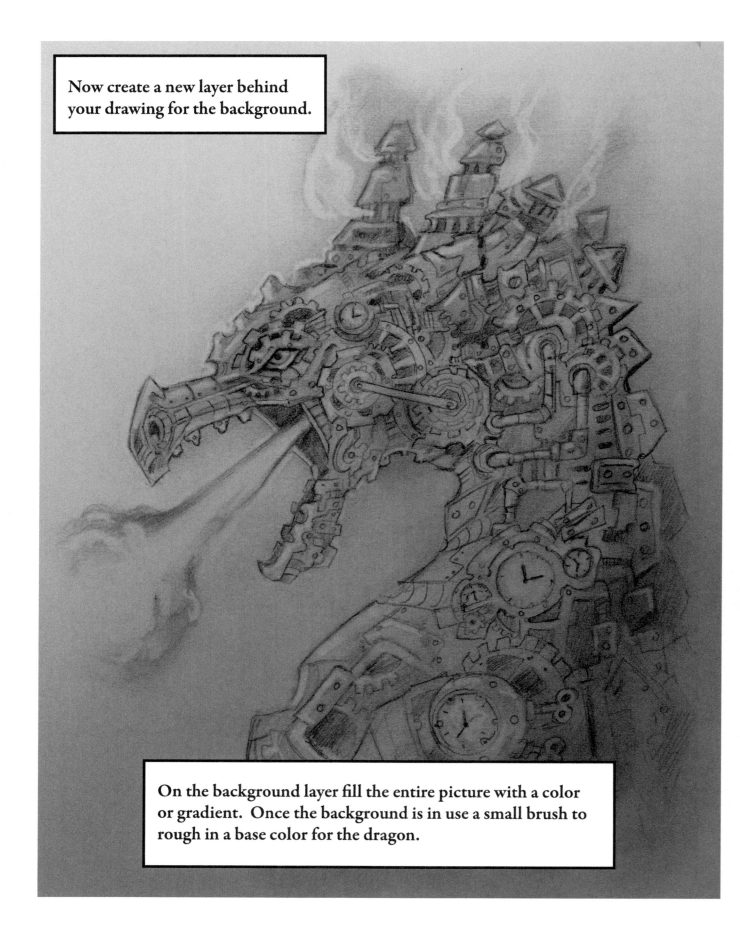

Now create a new layer behind
your drawing for the background.

On the background layer fill the entire picture with a color
or gradient. Once the background is in use a small brush to
rough in a base color for the dragon.

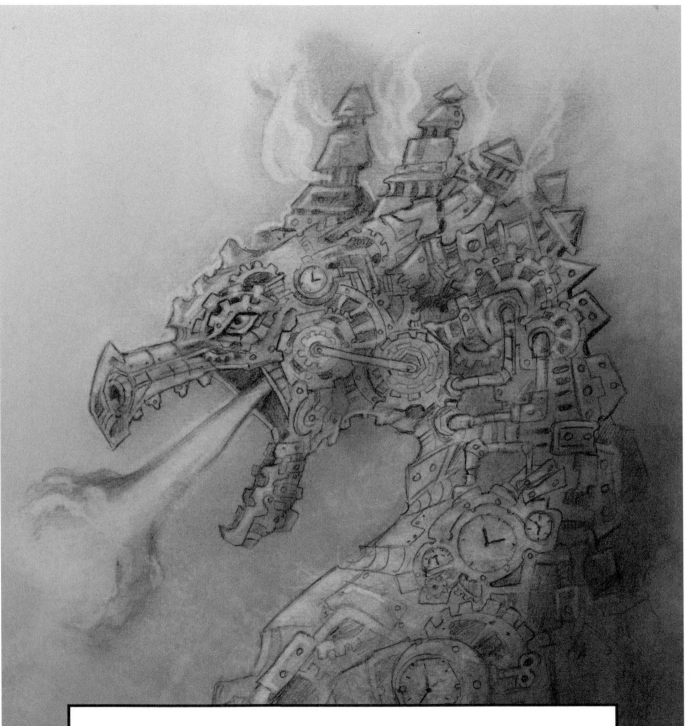

Now we can start adding colors! I like to use a brush with some texture (experiment and see what you like). Create a new layer (above the background and below the pencil drawing). I set my layer to "overlay" and paint in it with some brown, orange, yellow, and light blue.

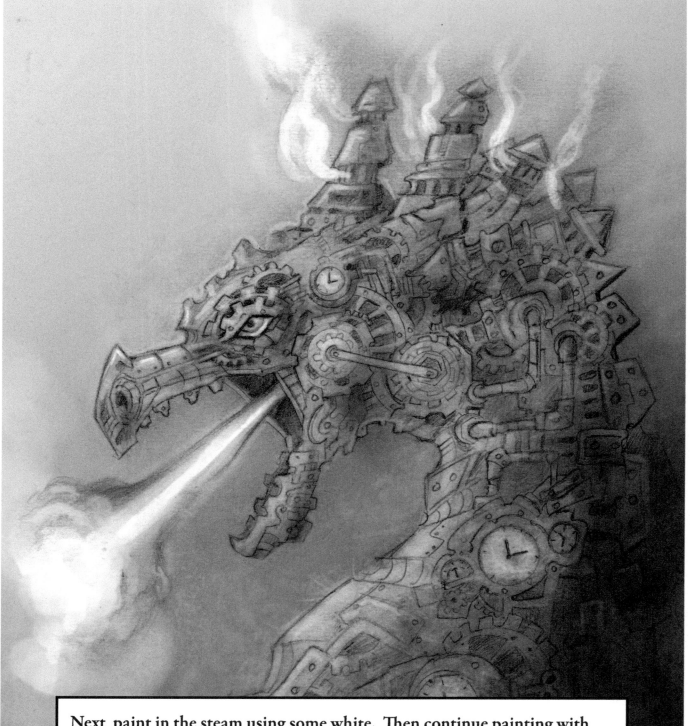

Next paint in the steam using some white. Then continue painting with "overlay" layers, using smaller and smaller brushes to add detail. I usually work a bit in a layer, flatten it when I'm happy with it and start a new one. I don't use a lot of layers when painting digitally because it can take away from natural blending that happens when you paint.

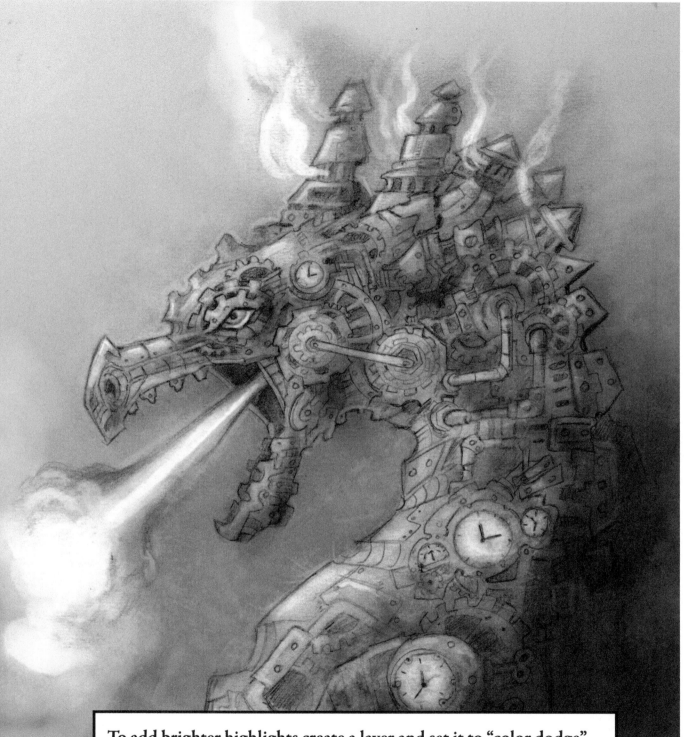

To add brighter highlights create a layer and set it to "color dodge" or just "dodge" and then paint in it with very dark colors (they will create bright glowing effects). Depending on the software you use you may need to experiment with different colors and layer settings.

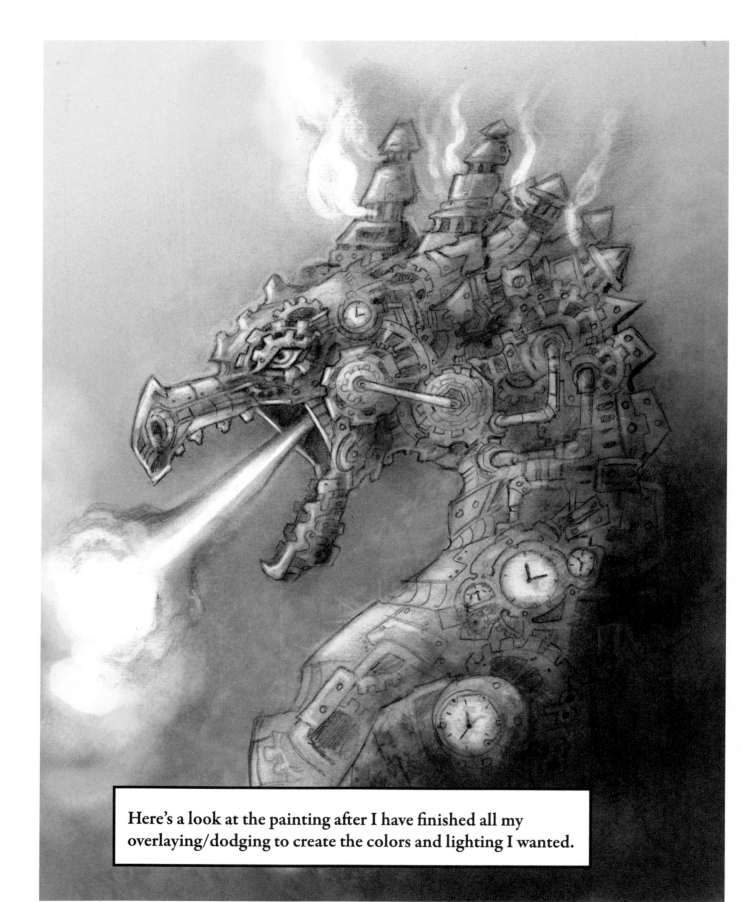

Here's a look at the painting after I have finished all my overlaying/dodging to create the colors and lighting I wanted.

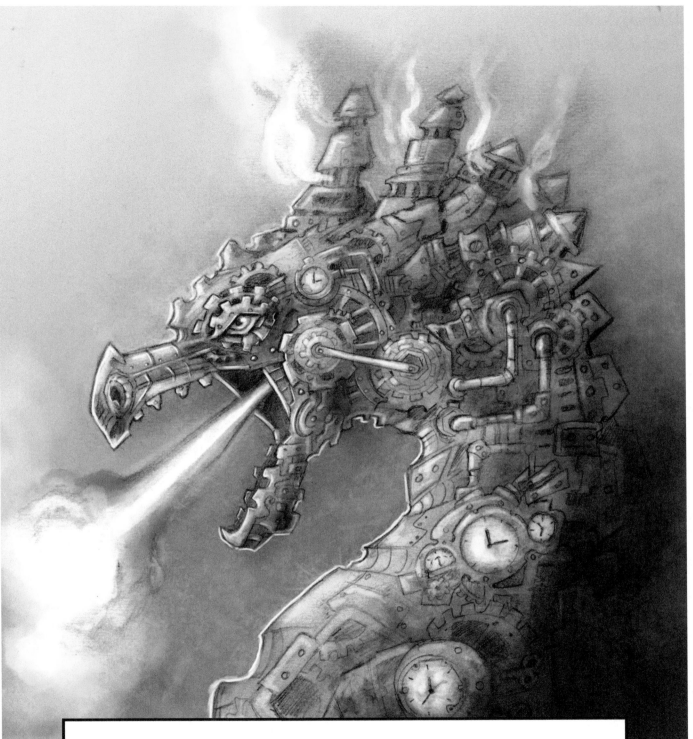

One last step: create a layer ABOVE your pencil drawing! Set this layer to "overlay" or "screen" (test and see what works best for you) and then use a very small brush and white to add highlights. This last step really makes the details stand out!

Black Cat
Pencil Sketch & Digital Painting

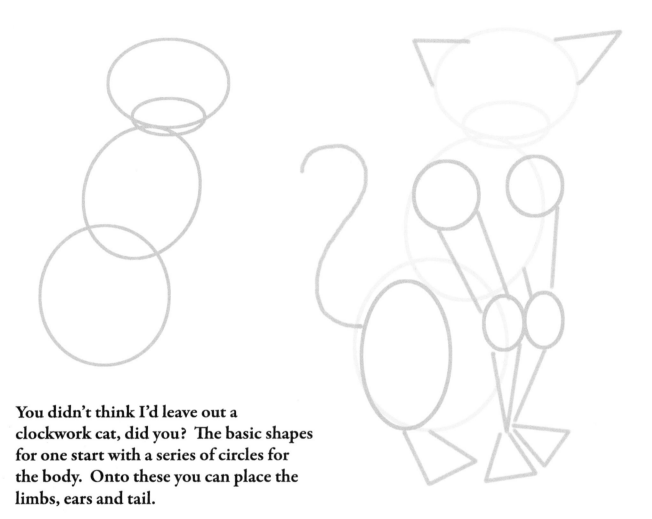

You didn't think I'd leave out a clockwork cat, did you? The basic shapes for one start with a series of circles for the body. Onto these you can place the limbs, ears and tail.

Let's look at breaking up the face shapes in more detail: The ears are triangles that are then divided with a line (the lower part is inside the ear). A few straight lines can be helpful to center the eyes. The nose is a triangle with an upside down Y at the bottom for the mouth.

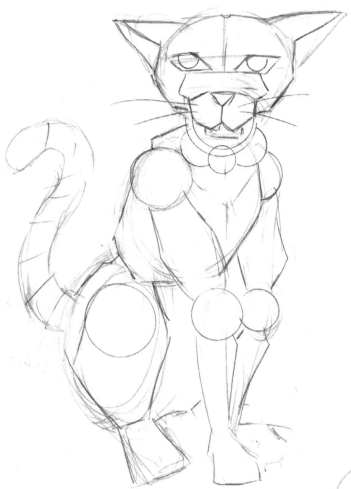

Here's the basic drawing for the cat. I used a template to place circles for some of the joints, in the eyes, and for the collar (I'm going to give my cat a gear collar with a clock in the middle).

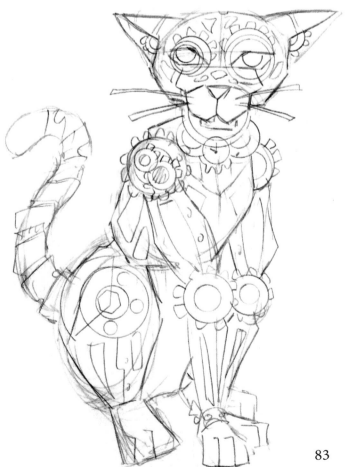

Now draw in all the detailed parts. Remember you can look at all the parts pages at the end of this book for ideas!

It's up to you if you want your cat's eyes to match or be different - I like making mine a little different (using different sized gears around the eyeballs etc) as it makes the cat look a little crazy.

At this stage you can finish the cat using pencil or ink or continue with this tutorial and use digital painting.

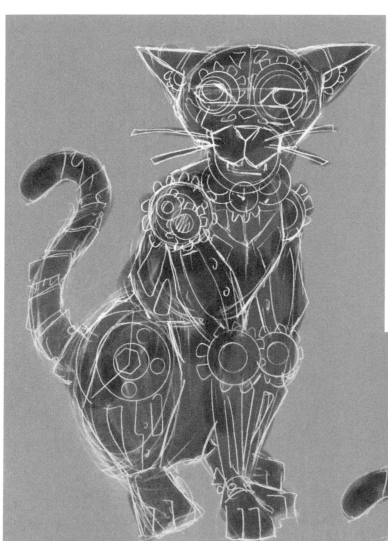

Since we want to create a black cat we want our drawing to be white. Most programs have an "invert" option or filter that will do this for you.

After the drawing is inverted set that layer to "Screen" and you will have your white drawing appearing over anything you add behind it.

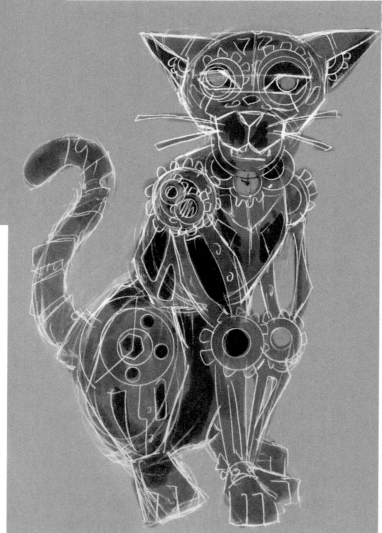

Now you can create a layer behind your pencil drawing and fill it (I used a blue-gray color) and then paint the body in with a darker color.

Continue to darken the body of the cat by adding shadows in the ears, on the tummy and so forth.

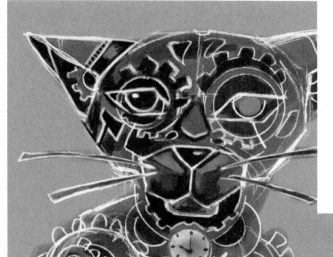

Next flatten all your layers and create a new layer at the top to paint your details on. You'll want to experiment with your software to see which brushes you like painting with best.

You will notice I've used a little light blue with my highlights. This is more interesting than just leaving it black and white.

Because I had only a rough sketch I'm defining a lot more of the details in the digital paint itself.

If you have a finished pen or pencil drawing (like those used in the other digital examples in this book) you won't need to do as much digital painting.

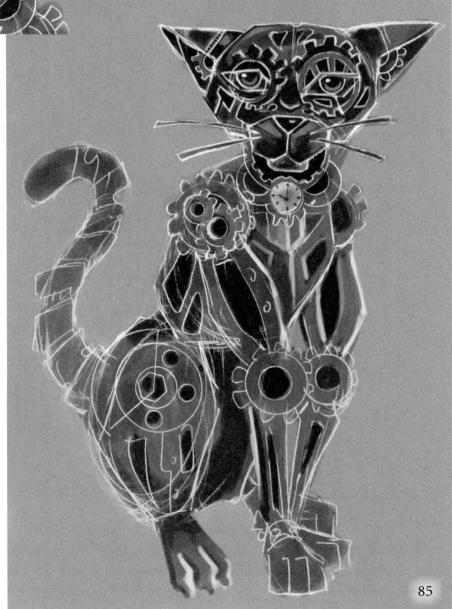

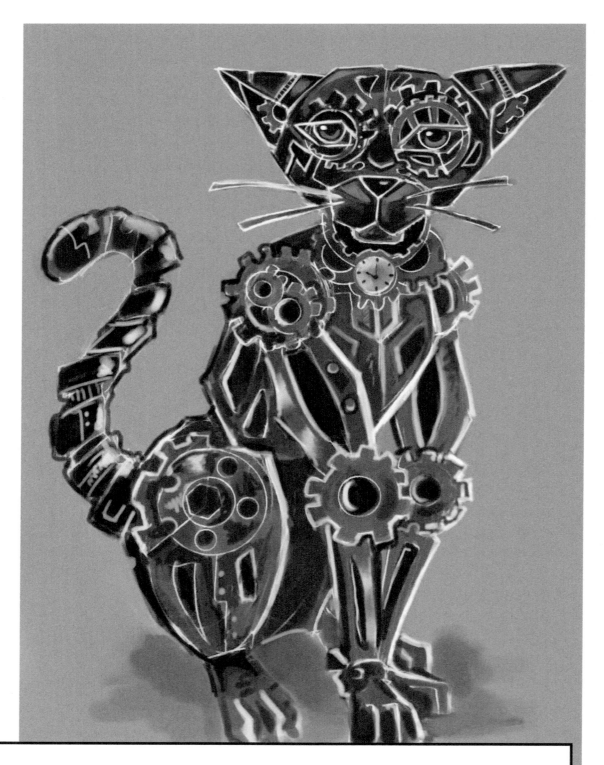

Here is my cat with the painting done. (I could continue to add to this if I wanted something more detailed but I'm keeping the cat fairly simple for this example). Notice the thicker bright highlights used to pop the edges out.

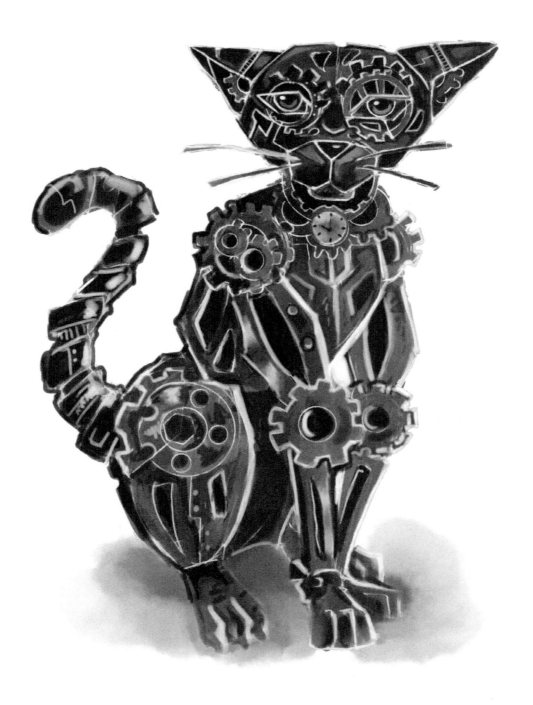

Optionally you can paint some additional colors on at the end as shown here. I used an "Overlay" layer to add the color to my cat and then merged all my layers, selected and deleted the darker background and blended the shadow under the cat out using a smudge tool.

The Parts

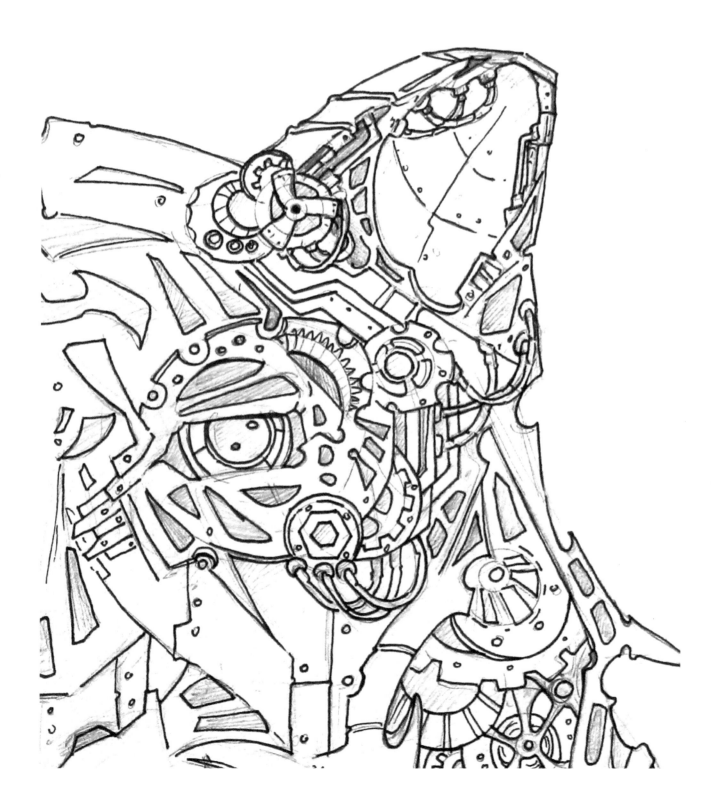

Clocks & Gages

Clocks and gages can be drawn wit
a few circles and then have details
like the clock hands, winding keys
and so forth added.

Make sure to look around you at
watches, pocket watches, and clock
for more ideas (antique watches an
jewelry are great for this!).

Winding keys are a few
rectangle shapes with
the key part at the end
looking like a number 8.

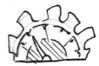

Gages can use full
OR half circles (they
look like rainbows).
You can even design a
square shaped gage!

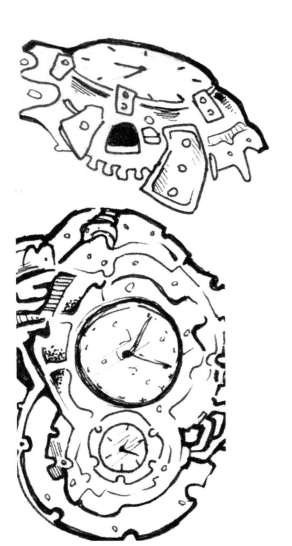

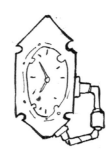

Add other parts like
pipes and gears to
make your clocks
more interesting!

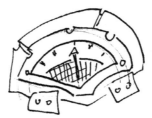

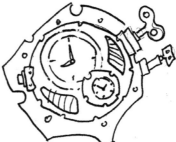

You can place
multiple clock
faces inside a
larger shape too!

Gears

Drawing gears is easy. Just start with three circles as shown at the right (a circle template can be handy for this). Use these to build different types of gears like the ones shown below.

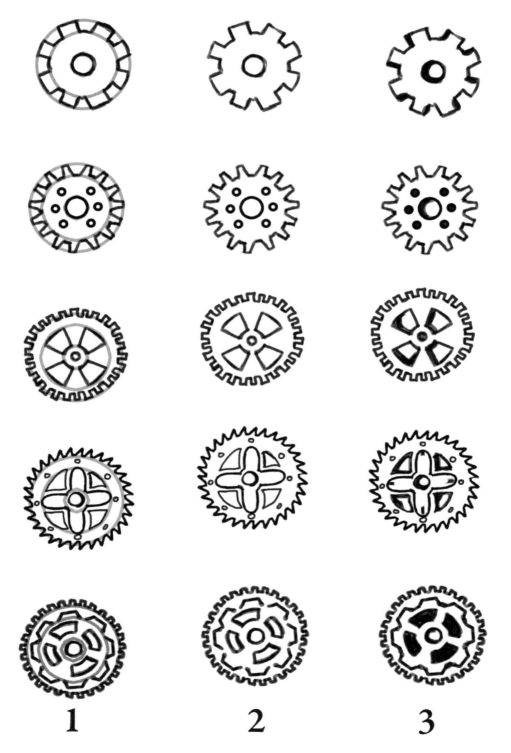

1 2 3

Overlapping gears will create much more interesting drawings! For example we can overlap the same basic circles to create guidelines.

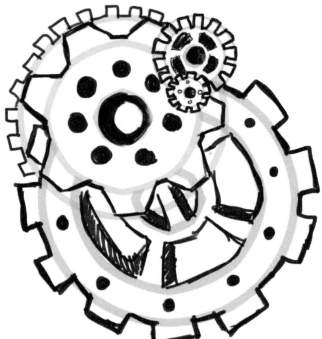

Then plan a bunch of gears overs the circles like this.

When the guidelines are erased... presto! A bunch of gears!

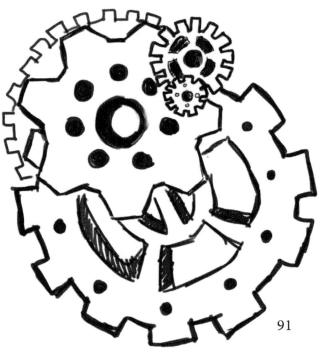

Eyes & Vents

Designing eyes is really similar to drawing gears. For the eyeball you may have some extra highlights to make the eye pop out. You may also have a brow or eyelids. The brow shape can greatly effect the mood of your creature. By creating a sharp angle and narrow eye the creature can look more angry while a wide eye can look innocent.

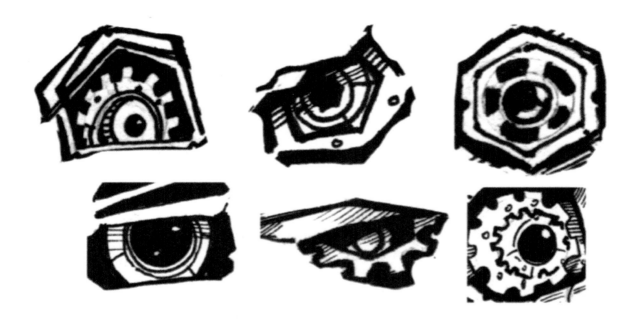

Vents are places where steam, air, gas, heat etc can escape (they may also be there to allow air in). These can be as simple as some slits or a grill in a circle or square. They might also have more of a smokestack design with vents at the top. Showing some smoke or steam coming out will help people know what it is.

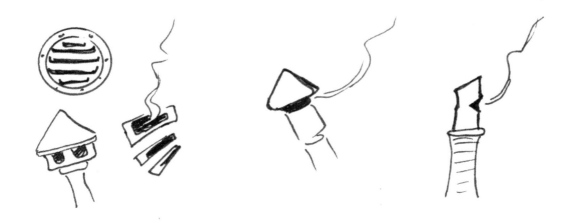

Cables & Pipes

Cables, pipes, and all sort of connectors can really add to your drawings.

These parts are created by taking simple shapes and then varying their size, overlapping them and so forth.

Consider showing patches, repairs and even leaks when you are drawing pipes!

Cables are similar to pipes but are less angular and more likely to get tangled!

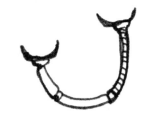

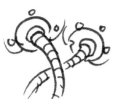

Remember to include junctions and even junction boxes for connections!

Wings & Fins

Drawing wings is easier than you might think! Start by placing circles for the joints of the wing. Connect them and then draw more straight lines sticking off.

Then just connect the straight lines using curved lines (arcs) and you have the basic wing shape!

How curved the arcs are is up to you - try a few different curves and see what you like!

Now you can add details like gears for each joint and shade inside the wings to create depth.

Drawing fins is very similar. Create a central shape (a circle or half circle works well). Then draw lines radiating out from it.

Connect those lines with curved lines (arcs) and you've got your fin shape! Fins work great on underwater clockwork, flying machines, and even on the sides of a dragon's head!

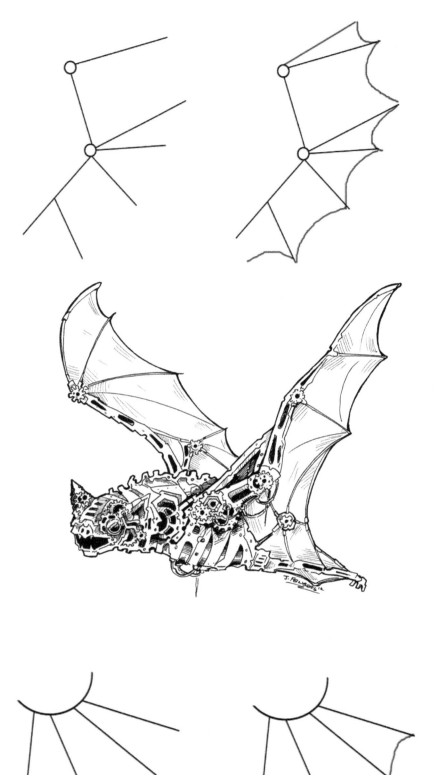

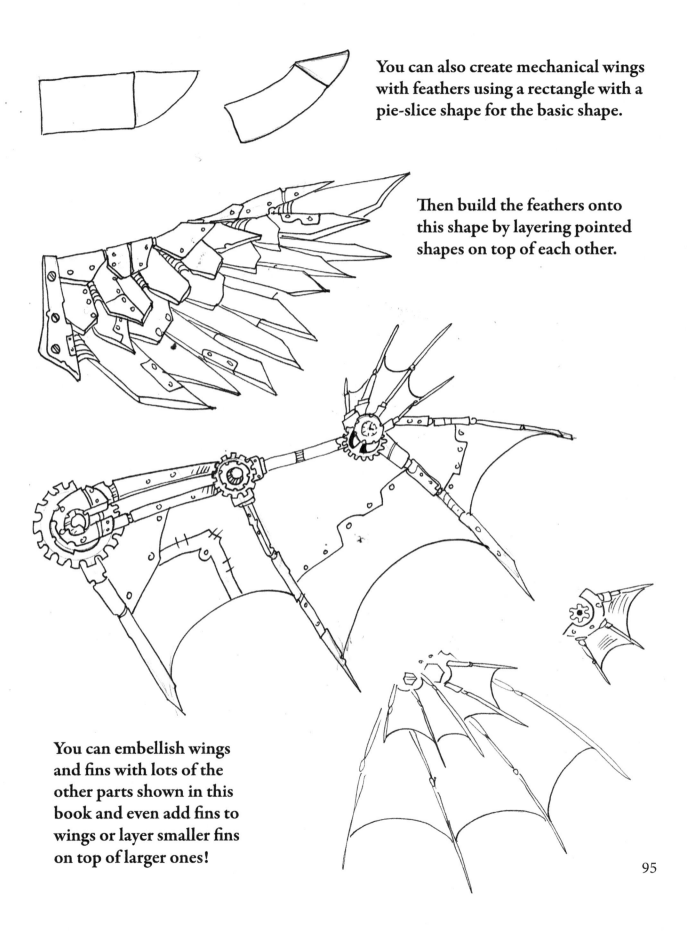

You can also create mechanical wings with feathers using a rectangle with a pie-slice shape for the basic shape.

Then build the feathers onto this shape by layering pointed shapes on top of each other.

You can embellish wings and fins with lots of the other parts shown in this book and even add fins to wings or layer smaller fins on top of larger ones!

Legs, Arms & Claws

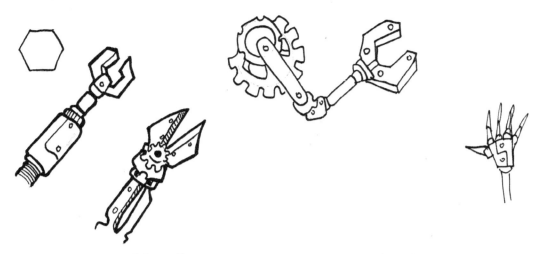

Drawing arms and legs for your creatures is easy. Take a look at the parts pages on gears and also pipes. Then put them together and add a claw, hand, or foot at the end! Pinching claws can be drawn using a hexagon or circle for the basic form. You can also try looking at wrenches, clippers, scissors and other tools for ideas.

Legs and feet generally tend to be a bit heavier and more supportive than arms, but you can also make them really skinny and give your creature lots of legs. Remember your limbs don't all have to match, even on the same creature!

Other Parts

There's LOTS of other parts you can add to your clockwork creations!

Try looking at cars, lamps, sinks and even musical instruments for ideas. Parts are everywhere!

You can make larger, more simple areas of your creatures more interesting by adding rivets (bolts) to the edges.

You can even add some decorative borders around these or overlap small patches to show repaired areas.

Try going to a big hardware store with a sketchbook for ideas.

<u>Thank you for reading this book!</u>
I hope it has left you inspired to go out and create
clockwork creatures of your own.

Remember: Everyone is creative and has the ability to make
amazing things, but many of us are afraid to try. Fear is
normal, but don't let it stop you from doing anything you
really want to do in life. Now pick up a pencil (or pen) and go

make some art!

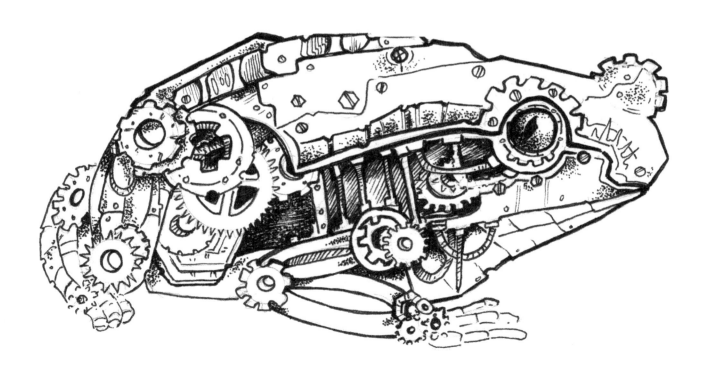

About the Author

Jessica Cathryn Feinberg is a driven, quirky, creative gal who resides in Tucson, Arizona with a house full of books, cats, dragons, and art supplies.

Jessica has been fascinated by goblins and other fae since she was very young and has dedicated her life to writing, drawing, painting, and following in the footsteps of mysterious creatures.

She is best known for her dragon, clockwork, and wildlife artwork as well as her field guides to rare creatures.

You can meet Jessica at many southwest events! For more information visit Artlair.com

CPSIA information can be obtained at www.ICGtesting.com
Printed in the USA
LVOW02s1440200815

450887LV00005B/7/P